HOOSIER AVIATOR
PAUL BAER

HOOSIER AVIATOR
PAUL BAER

AMERICA'S FIRST COMBAT ACE

TONY GAREL-FRANTZEN

THE
History
PRESS

Published by The History Press
Charleston, SC
www.historypress.net

Copyright © 2017 by Tony Garel-Frantzen
All rights reserved

Cover: From an original painting by Ivan Berryman. *Reproduced courtesy of Cranston Fine Prints.*

First published 2017

Manufactured in the United States

ISBN 9781467138499

Library of Congress Control Number: 2017948511

Notice: The information in this book is true and complete to the best of our knowledge. It is offered without guarantee on the part of the author or The History Press. The author and The History Press disclaim all liability in connection with the use of this book.

To Helene, Anna, Adam and Alex.

CONTENTS

Acknowledgements 9
Introduction 11

PART I. AN APPRENTICE HUNTER
1. Baer's Beginnings 15
2. Fledgling Birdman 21
3. "I Speared Another Hun" 31
4. Shot Down! 39
5. A Caged Birdman 49

PART II. THE RESTLESS RAPTOR
6. Hesitant Hero 65
7. Another War 71
8. D'Artagnan of the Air 77
9. Life After War 83
10. Fallen Birdman in Shanghai 93

Postscript 107
In Their Honor 111
Notes 113
Index 123
About the Author 127

Acknowledgements

N o project of this nature is ever successfully completed in a vacuum. Numerous helpers deserve my gratitude. I begin with the cover image, "1st Lt. Paul Baer," which is from an original painting by Ivan Berryman, reproduced courtesy of Cranston Fine Arts. Thanks also go to author Dennis Gordon (*The Lafayette Flying Corps*) and Carey Massimini of Schiffer Publishing Ltd. for their permission to use citations. A hearty thank-you goes to Walter Font and his staff at the Allen County–Fort Wayne Historical Society for their kind assistance in providing rare materials that add rich detail to the story of Lieutenant Baer's life.

The author also is grateful for the invaluable help provided by Allison DePrey Singleton at the Allen County–Fort Wayne Public Library Genealogy Department. Finally, a salute to Lieutenant Baer, my father, my father-in-law, an uncle I never got to know and all those who fought and died to protect us: Thank you for your service and your iron determination to ensure the triumph of good over evil so that we may enjoy our freedom today.

Last but not least, many thanks to John Rodrigue, Ryan Finn and The History Press staff for helping tell a hero ace's story.

INTRODUCTION

Artillery. Cavalry. Infantry. In his book *Heroes of Aviation*, Laurence La Tourette Driggs observed that for centuries, nations placed their faith in these three venerable military tools to achieve strategic goals and obtain ultimate victory in war. Together, they were unchallenged in their exclusive hold over the ability to deliver the pinnacles of achievement in military conflicts.[1]

Unchallenged, that is, until the dawn of the twentieth century. Orville and Wilbur Wright changed this long-standing military arrangement with the success of their Wright Flyer at Kitty Hawk in 1903. With the introduction of the airplane, control of the air rapidly became not only the fourth tool of military forces but also the primary requirement for a victorious offense or defense in the twentieth century.

Aviation pioneer General Henry H. "Hap" Arnold, a visionary in the use of air power, once observed that "a modern, autonomous and thoroughly trained air force…will not alone be sufficient, but without it there can be no national security."[2]

It did not take long into World War I for each side to recognize the advantage in sending aloft observers—first in balloons and then in flying contraptions made of wood, fabric and glue—to help track even the smallest movement of enemy forces. Military planners reaped the benefits. Camouflaged artillery became revealed. Massing of men and machinery could now be foreseen. Few places afforded true hiding from these aerial scouts, whose wicked sister, the artillery, could then pummel sites beyond recognition.

The dangers in perfecting this new tactic were many and ever-present. Yet the furious pace of war forced the aviation industry through a whirlwind of changes and ultimately produced three types of combat aircraft: fighters, observation planes and bombers.

Sadly, for purposes of posterity, few living in the twenty-first century recall the absolute horror that the "war to end all wars" reaped on Europe. Two examples are illustrative. The British lost 20,000 infantrymen on one day at the Battle of the Somme. The French suffered 250,000 casualties at the Battle of the Marne. Civilians, horrified at such carnage, sought relief. They found it in the skies over Europe.

In this work, readers will follow the life of America's first aerial combat ace and his daring quest to engage in modern-day jousts in the sky battles that were reminiscent of knights competing in tourneys of old. These knights of the air helped provide relief to the large-scale horrors of combat. Millions of deaths occurred on the ground from all causes during World War I. By contrast, fewer than fifteen thousand airmen were killed in battle in the air in all theaters. Daring young men like Paul Baer, in their dashing uniforms and performing heretofore unimaginable feats of aerial acrobatics, provided distraction to civilians weary of the bloodbath caused by the wholesale waste of entire generations of men in the carnage and unspeakable conditions of trench warfare.

Why did men like Paul Baer, their average age in the early twenties, trade the normalcy and the security of civilian life to test their destiny in the new air war? Some sought to escape troubled pasts. Others were drawn to the romance of the adventure in a far-off land. But few had an accurate understanding of the true risks they were about to face.

Whatever the reasons, we remain indebted to Paul Baer and all those brave airmen whose efforts and contributions wrought a righteous outcome from those terrible times.

PART I
AN APPRENTICE HUNTER

CHAPTER 1

BAER'S BEGINNINGS

L ike most years in human history, 1866 served up a potpourri of
contrasting events ranging from the trifling to the triumphant, the
tedious to the transformational.

Americans grappled with the work of uniting the nation after four
years of bitter civil war. The first daylight armed robbery of a bank in
peacetime occurred in Liberty, Missouri, courtesy of outlaw Jesse James.
Anne Sullivan, born in Massachusetts, was destined to be instrumental
in helping Helen Keller overcome the dual scourge of being deaf and
blind. In Cincinnati, the Red Stockings baseball club, predecessor of the
modern-day Cincinnati Reds, was organized in July. Robert Leroy Parker
was born in Utah and set forth on his journey to be a professional robber
of trains and banks. Most know him better as Butch Cassidy, leader of
the Wild Bunch gang. A Quaker pharmacist invented what we now call
root beer. No doubt creatures everywhere breathed a sigh of relief upon
learning the American Society for the Prevention of Cruelty to Animals
(ASPCA) was founded in New York City.[3]

The story of Paul Baer also has its beginnings in January 1866. Many
of the early facts about his family life have faded in the foggy passage of
time. A timeline from the precious few details still recoverable begins with
his mother.

As the country welcomed in the new year, Hiram and Emeline Parent also
welcomed their fourth child, Emma. According to the 1870 U.S. Federal
Census,[4] Hiram Parent, forty-seven, was an Ohio farmer, and Emeline Kegg,

thirty-five, reported her occupation as "keeping house." Their daughter, Emma, was born in Fort Wayne (Allen County), Indiana. She joined the Parent family, which already included two girls and a boy: Mary, fourteen; William, ten; and Kitty, four.

Three years earlier and a mere thirty-two miles to the west of Fort Wayne in Cecil (Paulding County), Ohio, Emma's future husband was born. Benjamin Baer and his wife, Amanda Buttermore, gave birth to Alvin E. on March 13, 1863. Meanwhile, when Emma was four, her parents moved their family to Milan, Indiana, about eighty miles to the southeast of Indianapolis in Ripley County.

How Emma's path crossed with Alvin's we cannot be sure, but cross it did. They were married on January 18, 1887, in Allen County, Indiana.[5] She was twenty-one and Alvin was twenty-four. Christmas that year brought them a present in the form of a daughter, Mabel Naomi, born on December 25.

The following summer, Emma's mother, Emeline Kegg, died on July 25, 1888, at the age of fifty-eight. A second child, Arthur, was born in May 1892. The Baers' third child, Paul Frank, was born on January 29, 1894. Emma lost her father, Hiram, on November 1, 1899, at the age of eighty. Perhaps her grief was eased by the birth of her fourth child, Alvin Webster "Buddy" Baer, nine days later.

Paul, who had hazel eyes, brown hair and rosy cheeks, attended Nebraska Elementary, Jefferson Middle School and Clay School. Elma and Alvin's marriage was falling apart during this period. Perhaps it was the pressures of raising four children. Or perhaps Emma or Alvin—or both—had wandering eyes or hearts. In any event, when Paul Baer was twelve, his parents divorced. An unemotional, one-line notice in the local newspaper summed up the end of their nineteen-year marriage: "Emma Baer was granted a divorce today by Judge O'Rourke and given the custody of the four children."[6] Alvin, an engineer on the New Orleans and Mobile division of the Louisville and Nashville Railroad Company, relocated to Mobile, Alabama. Time passed, and on August 31, 1908, Emma married Frederick E. Dyer in Detroit, Michigan. Born in Michigan, Dyer's occupation was listed as a miner.[7] Dyer was thirty-two, and Emma was now thirty-eight; they lived on Hollman Street in Fort Wayne.

Thanks to one historian's effort,[8] some of the highlights of Baer's early days have been preserved. In *Paul Baer Scrapbook*, author Herb Harnish noted that one of Baer's first jobs was working as "an office boy to Oscar Foellinger,"[9] who became publisher of the *Fort Wayne News-Sentinel* in 1916. Foellinger was the son of a shoe manufacturer, served as business manager

for the *Fort Wayne Journal-Gazette* and spent two years as an accountant on the West Coast. Foellinger later died of a heart attack while on a hunting trip in Canada in the fall of 1936.[10]

From his early days, the diminutive five-foot-eight Baer very much disliked being in the spotlight and was even more averse to talking about himself. Alvin Baer once told a reporter that "Paul is the most timid of our four children. His sister [Mabel], the oldest child, fought all of the battles at school. And she made a finished job of it." But Baer overcame at least some of his childhood timidity in the skies over France. Said his father to the reporter, "Fighting has been Paul's game for some time."[11] The same could be said for Baer's aptitude for mechanics.

With the advent of the car, most Indiana cities within two hundred miles of Detroit became part of the massive automobile industry after 1910.[12] Not surprisingly, Baer's "early interest in mechanical things" resulted in his enrolling in the Cadillac Automobile Company's School of Applied Mechanics in 1911 in Detroit, where he "was employed as an apprentice machinist, despite being a high school dropout."[13] He earned a certificate from the school after two years of study—"the longest period of time he would remain in one place for the rest of his short but colorful life."[14]

Meanwhile, six years was apparently all that Emma could tolerate of her second husband, Frederick Dyer. Like her first divorce, Emma's second marriage ended on a day in November, this time in 1914. Apparently, Mr. Dyer had a temper, as indicated in the "Courthouse News" roundup in the local paper:

> *Thanksgiving week has brought no relief from the flood of divorce complaints pouring into the local courts and the troubles of mismated couples continue to be brought to the courts for settlement. Emma B. Dyer wants a divorce from Frederick E. Dyer. She also wants alimony in the sum of $1,000 and an order restraining the defendant from visiting or molesting her. Mrs. Dyer's chief cause for complaint is that her husband has threatened to "knock her brains out." She does not fancy this proceeding any more than she does his habit of spending too much of his money for booze, she says, so she wants to get rid of him. Harper and Fuelber are attorneys for the plaintiff.*[15]

Baer[16] was about to embark on a series of globe-trotting adventures. As Herb Harnish put it, "Reviewing the activities of Paul Baer leads one to believe that he adopted as his creed Teddy Roosevelt's statement that men should lead lives like a cavalry charge."[17]

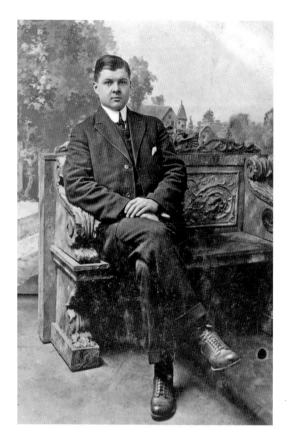

A portrait of Baer taken in January 1916 while he was in Detroit. *Paul Baer Collection, Allen County–Fort Wayne Historical Society.*

For Baer and hundreds of other adventure-seeking young men in the early 1900s, they indeed would charge ahead with their lives in a cavalry the likes of which the world had never seen—an air cavalry. However, first would come a call to action from south of the border: "Eleven Americans Are Shot Down When Mexicans Conduct an Armed Invasion of New Mexico."[18] This was the newspaper headline that greeted residents of Fort Wayne as they awoke on a cold and gray Thursday, March 9, 1916. A smoldering conflict on the Mexican border had come to a head in Columbus, New Mexico. The *Fort Wayne News* reported the following:

> *Invading the United States at the head of about 500 mounted followers, Francisco Villa attacked this little town* [Columbus, New Mexico] *guarded by 300 American cavalrymen, applied the torch to its principal buildings and before finally driven back into Mexico after two hours' desultory firing, killed four United States troopers and at least seven*

American civilians. Only the desperate bravery of the outnumbered American soldiers prevented a massacre greater than the slaughter of eighteen helpless Americans at Santa Ysabel, Mexico, Jan. 10. Pablo Lopez, who led the Villistas in the Ysabel massacre, is reported to have been with Villa in the attack on Columbus at 4:30 a.m. today. Three Americans Villa held prisoners before the raid on Columbus are reported to have been killed and their bodies burned.[19]

According to the U.S. Army Center of Military History, "elements of the 13th Cavalry repulsed the attack, but there were 24 American casualties (14 military, 10 civilian). Immediate steps were taken to organize a punitive expedition of about 10,000 men under Brigadier General John J. Pershing to capture Villa."[20] These steps included a call-up of various military units, including the Indiana National Guard, to perform patrols along the U.S.-Mexico border.

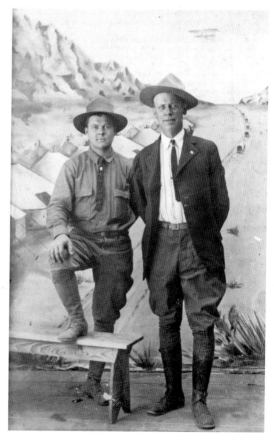

Baer and a friend take time out for a photo while chasing Pancho Villa in 1916 in Mexico. *Paul Baer Collection, Allen County–Fort Wayne Historical Society.*

Baer, now twenty-two,[21] was stirred by the news and left civilian life to serve "with the Indiana National Guard as a truck driver in the Mexican Border Campaign."[22] Although members of the Indiana National Guard engaged in no action, their time served on the U.S.-Mexico border "provided a dress rehearsal for the general mobilization for World War One."[23]

Baer's service in the Mexican Border Campaign held his attention for less than a year. In late 1916, a higher calling summoned him in a new direction.

CHAPTER 2

FLEDGLING BIRDMAN

The United States maintained a neutral position at the outset of World War I in August 1914. But for some young Americans, the lure and romance of joining the battle against Germany to defend a long-standing bond linking America to France was too much to resist. American volunteers signed up to fight with the French in the trenches, serve as corpsmen attending the wounded and answer the desperate call for ambulance drivers to transport the thousands of soldiers wounded in combat.

As the role of the airplane took on increasing importance, however, French leaders quickly realized that "the presence of a band of young Americans in French uniform, fighting the spectacular battles of the sky, would be certain to arouse a widespread interest and sympathy" in the United States.[24] However, what to call the outfit they served with got mangled in the process:

Considerable confusion exists in the minds of many persons about the difference between the Lafayette Escadrille and the Lafayette Flying Corps. This famous aeronautic body was the Section d'Aviation of the Legion Etrangere in the early days of the war. To mark the number of Americans who were sharing the dangers and victories the name was changed to the Franco-American Flying corps. But as the United States was not then at war with Germany [a] complaint was made that this was a breach of neutrality. To avoid giving offense the name was changed to the Lafayette Flying Corps, which is the present designation.[25]

America's arrival in the war in April 1917 further complicated matters. "The first aero squadrons of the U.S. Air Service that went into combat in France during World War I were under the tactical control of French and British units, and the victory credits earned by members of these units during this period were confirmed and recorded by the French or British." Once U.S. squadrons were reporting to the American Air Service, a program for crediting victories was put in place.[26]

The impact this miniscule group of American volunteer pilots had in the early days of the war played a key role in forming the tide of public opinion that stirred America's decision to enter the war. Yet according to one American pilot, he and his colleagues were oblivious to the role they played and wouldn't have cared had it been pointed out because they were occupied with other matters:

> It was a virulent disease known as "the unconquerable pioneering spirit of our hardy forefathers" that led most of us into sticking our noses into something where we had no real business. And I'll wager that just like us, if they could have only been brought to admit it, those "hardy pioneers" had plenty of moments when they wished they'd stayed where they were and minded their own affairs. None of us had any real idea of what we were getting into. We had hold of the bear's tail and no one to help us. With few exceptions, I believe most of us would have welcomed an opportunity to bow out gracefully.[27]

The reliance on foreign volunteers was not without concerns. French officials expressed misgivings at Americans and other foreigners enlisting in the French army for two reasons: "One was the need of ceaseless vigilance against spies. In the second place, there was no place or need for volunteer aviators. Hundreds of young Frenchmen were clamoring for admittance."[28] But the demand far exceeded the relatively few vacancies available. Still, the exploits of the pilots, publicized by press on both sides of the Atlantic Ocean, generated widespread interest among young American men.

The French ultimately concluded that no international law prevented U.S. citizens from joining the French military provided their recruitment did not take place in America. Desperate for American support, the chief of French Military Aeronautics agreed near the end of 1915 to assemble all American flyers into one squadron. The following year, American aviators flying with various squadrons in the French army were reassigned into one unit, called the *Escadrille Americaine* (ultimately renamed the Lafayette Flying Corps). As

its reputation grew, young American men could not resist the lure of this daringly different kind of adventure:

With the advent of aviation in warfare a new call was sounded to attract the adventurous and strong. The very love of sport itself seemed to spiritualize the aviators' service at the front. With its natural appeal to those instincts of sportsmanship with which every youth is endowed, the Flying Service at once became the Mecca of every young hero's desire. Rivaling the romance and glory of the tales in Greek mythology these free lances of the air went daily forth to dazzling adventure and awakened anew the chivalrous pride of old-time combat. The whir of their aeroplanes in the limitless skies never failed to attract the interest and admiration of the world below—be that world friend or foe. Into this glamour of war went, early in the year 1915, a group of young Americans who were actuated by a common impulse to hurl their strength against the spoilers of Belgium long months before their tranquil fellow-countrymen at home awoke to the dreadful necessity of defending themselves against the same dire peril.[29]

Paul Baer was no doubt "actuated by a common impulse" when he decided to depart Fort Wayne for Europe in early 1917. In fact, when the Mexico Border Campaign ended, "Baer was so anxious to participate in actual aerial warfare that he signed as a horse tender aboard a steamship carrying stock from the United States to the allies."[30] According to the National Archives, Baer applied for his passport in January 1917.[31]

Baer's services as a hostler paid his passage on the ocean liner SS *Rochambeau*, named after a French nobleman and soldier who served in the American Revolutionary War. Baer enlisted in France's *Service Aeronautique* on February 20, 1917, and prepared to begin his training.

Like all pilot candidates, Baer's first stop was an appointment with Dr. Edmund L. Gros, an American who served as the examining physician, at 23 Avenue du Bois de Boulogne.[32] Here, Baer and other aviation recruits received a complete medical workup:

Upon his arrival in France, the candidate presented himself to Dr. Gros, who oversaw all aspects of the Corps' overseas operation. He first examined the man's credentials then gave him a physical before sending him on to the Bureau de Recrutement at the Invalides [i.e., the *Hotel des Invalides,* the headquarters for the French Foreign Legion]. *The American candidate* [also] *signed a special enlistment form which would allow him*

to be released outright should he prove to be inept at flying—a guarantee he would not be forced to serve with the [Foreign] Legion in the trenches. Dr. Gros' approval of a candidate assured his acceptance in aviation.[33]

Like all the candidates at the *Bureau de Recrutement*, Baer would have been given "an optical test that consisted of reading an eye chart 'the size of a billboard.'" The required paperwork during the candidate's induction was abundant. Once his enlistment forms, service agreements and medical records were properly completed, Baer was ordered to the supply depot at Dijon, a five-hour train ride 196 miles southwest of Paris. There, he would "sign more papers, be outfitted in a uniform, and pick up his flying equipment. Finally, he was given a railroad ticket to the French flying school where he was assigned."[34]

The flying equipment included goggles, leather jacket, gloves, pants and a crash helmet, the latter of which was apparently unpopular among the students, one of whom called it "a marvelously constructed Tower of Babel":

Sometime I should like to meet, in private, the massive-brained gorilla who designed the thing and, now that it wouldn't mean another eight or ten days of prison, tell the brass hats who made us wear them just what, in unexpurgated terms, I think about that ponderous headgear. It's a certainty that the engineer and the draftsman who drew the plans for it never had to wear one. It was built in layers, like a Chinese pagoda. It weighed just short of a ton. In it was an arrangement of springs and cork. It had an elastic chin band which was supposed to hold it in place. The theory was that if one overturned or suddenly stopped and got pitched out on the topknot, the crash helmet would prevent a fracture of the skull. A broken neck from the weight of the thing was much more likely to result.[35]

A pilot candidate also was issued a second-class French *poilu* (infantry soldier) uniform with shoes. "These he had to purchase at a cost of $50 in francs, the sum to be taken from his allotment expenses from the France-American Flying Corps fund."[36] The American volunteers had enlisted as *soldats de deuxieme class*e, or the equivalent of privates.

In the beginning of the war, pilot candidates trained at various sites, including Pau, located near the Spanish border. Some also were assigned to Buc in the vicinity of Paris. But most, including Baer, attended *Ecole d' Aviation* in the city of Avord[37] in central France. This is where Baer trained

to become an *avion de chasse*, or pursuit pilot, and received his *brevet militaires* (commission).

Although the press fashioned volunteers like Baer as supermen or iron men, in reality they were a mixed bunch:

> [It] *was a strange potpourri of types thrown into the great melting pot of the war. We came from all walks of life. Rich and poor, college men and boys whose only education had been in the school of hard knocks. A devil's brood of grousing, reckless, undisciplined, irresponsible wildcats, all a trifle screwy for to be war aviators we had to be just a little nuts. Motives were as varied as the men themselves. Some sought adventure, others revenge, while a pitiful few actually sacrificed themselves in the spirit of purest idealism.*[38]

For Baer and the other pilot candidates, they had entered an intriguing but challenging world where if they were going to provide any competition to other winged creatures of nature, they would have to complete a "simple and decidedly novel system of training."[39] The days were filled with both danger and boredom:

> *This was a risky world the young American was about to enter into with its omnipresent threat of injury or death. His day would be composed of long hours of waiting to accomplish short periods of flight, a routine which too often was only interrupted by lightning-quick crashes of breaking wood and rising dust. The normal time to receive a brevet militaire* [commission] *was approximately three months. This, of course, depended upon the weather, the size of the student's class, and his ability.* [One candidate] *who held a civilian pilot's license, earned his brevet in 18 days. As many as 800 students were training at a school at any given time, and the air overhead was constantly filled with the drone of engines.*[40]

In the unusual French system for producing pilots, a student was alone in the plane from the first time he entered the cockpit throughout all ensuing levels of *brevet* training. However, some students received training in twin-seat Caudron G-3 biplanes, including Baer.

Instructors at the schools were chosen from older pilots who had been injured or who had their fill of combat. Their purpose was to explain each step, note mistakes and require the student to demonstrate corrective measures when necessary. Training schools were anything but luxurious: "[The] schools were no bed of roses. We were up every morning before

dawn, with only a cup of lukewarm chicory [a drink made from a plant of the dandelion family], masquerading as coffee, to sustain us till the first meal at eleven o'clock."[41] While gulping down the chicory, a pilot candidate hurried to "the wash house where he showered and shaved in cold water before rushing back to his unheated barracks. There, he quickly donned his flying outfit which consisted of leather jacket and pants, gloves, goggles, and a leather-covered cork crash helmet."[42]

The training schedule for Baer[43] and other pilot candidates was conducted Monday through Saturday, with Sundays off. At daylight, candidates waited for their turn for instruction. Class cancellations occurred frequently because of bad weather and turbulent air, the latter especially during midday, when thermal warming from the sun caused updrafts. In the beginning, the word *flying* took on a relative meaning, given the instruction methodology employed by the French. Having a French instructor also made it particularly helpful, although not mandatory, for the pilot candidate to have a working knowledge of his instructor's native language:

> *The first level of training the student pilot entered was the Penguin class. Here, he was to train on a Bleriot monoplane with a wing area so small in proportion to its weight that it was impossible to fly. It merely rolled along the ground at a speed of fifteen to thirty miles an hour. All flying instructions were given in French. An interpreter had been provided for by the Franco-American Committee, but he could not be everywhere at once. Still, the Americans had little difficulty in understanding their French monituers* [instructors] *who were skilled in making their instructions understood through elaborate gestures. Running the Penguin on a straight path was no easy task. The airplane seemed to possess a will of its own and without apparent warning would swerve suddenly, or fall into a chevaux de bois* [merry-go-round loop] *much like a dog chasing its tail, often colliding with another Penguin coming from the opposite direction. As a result, the casualty rate among the Penguins was high.*[44]

When Baer was capable of steering the *Penguin* in a straight line, his instructor allowed him to take control of a Bleriot *Rouleur*, which had a more powerful engine and longer wingspan. The goal for the candidate was to stay on the ground and move forward along a straight line. It didn't always work that way:

This plane could fly after a fashion, but the student's job was to keep it on the ground. The usual result was that the student would forget his instructions and would soon be crow-hopping across the field in fifteen to twenty-foot-high jumps. The terror of this experience often wiped the emergency instructions from his memory, that he was to "blip" his motor off, and invariably he would crash his plane. However, this inadvertent hopping was exactly what his instructor wanted him to do, as it was the first step to learning how to take off and land his aircraft.[45]

Once the *Rouleur* was mastered, Baer moved up to a Bleriot with a fifty-horsepower engine. Real flying was next. Candidates were allowed to go up only when calm air prevailed, which typically was subject to numerous restrictions:

In anything except the most favorable combination of circumstances, such as a perfectly perking motor (a great rarity) and absolutely calm air, without a trace of wind or heat bumps, keeping a Bleriot under perfect control presented somewhat of a problem to the student pilot. Practically all flying with them ceased at ten o'clock in the morning, when there was likely to be a breeze and the air a little bumpy from the heat of the sun, and wasn't resumed till late in the afternoon, when the breeze died down and the air was presumed to have calmed off.[46]

Starting at sustained flights eight feet above the ground, instructors gradually authorized higher altitudes as ability and confidence grew until Baer was flying at one thousand feet above ground. Practice included landing the plane with the motor on and the motor off, learning to navigate with a compass, correctly reading the altimeter, understanding various uses for the clock and incorporating the use of maps. Finally, Baer graduated to a sixty-horsepower Bleriot and prepared to earn his military *brevet*.

Earning the *brevet* rested on three tests. First, Baer was required to complete two forty-mile trips. This involved flying to a destination marked on a map by the instructor where he would land and have his logbook signed and validated. Then he had to fly back within a set time limit. Second, Baer was required to successfully fly two triangular patterns:

Each must consist of a three-lap flight; the combined distance of these laps must total 150 miles; a minimum altitude of 3,000 feet must be maintained; the student pilot must land at two previously specified

intermediate points, so marked on his map, before returning to his starting point. Finally, he must complete the voyage within forty-eight hours. The normal triangle route was an air journey from Avord to the two intermediate points, and back to Avord. When the student reached these locations, usually landing fields near towns, he was required to land and have his papers examined and signed by a local official. He must also present his tamperproof barograph [a self-recording barometer] *and have its time and altitude read and certified. When he had accomplished both landings, he was to return to the aerodrome.*[47]

This was easier said than done. The student could only rely on a map and compass, using landmarks that were often obscured by clouds or fog as he flew along at three thousand feet. Engine troubles, disorientation and poor dead reckoning (using distance and direction traveled to determine the plane's position) often resulted in emergency landings, sometimes with fatal results. But if one successfully completed the triangular voyage, the final test involved altitude:

To pass this test, he must reach an altitude of 6,000 feet within a given time and maintain that altitude for more than one hour before returning to the aerodrome. The student's barograph recorded whether he had accomplished the test. When the student had successfully passed this altitude test, he received the Aero Club of France pilot's brevet and France's International Aeronautical Federation license.[48]

Baer earned his *brevet militaire* on June 15, 1917, in a Caudron G-3 biplane. His grade, as noted on his identification card,[49] was elevated to the rank of *caporal*, which included a pay raise. Advanced training followed, including map reading, knowledge of winds, machine guns, air-to-air shooting, aerial communication, aerobatics and formation flying. Next, he spent time at *Groupe des Divisions d'Entrainment* (GDE), located near Plessis-Belleville, about thirty miles from Paris. It was the bustling final stop before being assigned to the front:

The G.D.E. swelled with activity as pilots arrived and departed daily by train. The usual stay for the novice pilot was a period of from ten days to three weeks. During this time he was to fly officer observers on long trips over friendly territory while they trained themselves on taking photographs, spotting dummy batteries, and perfecting the wireless code. The novice pilot

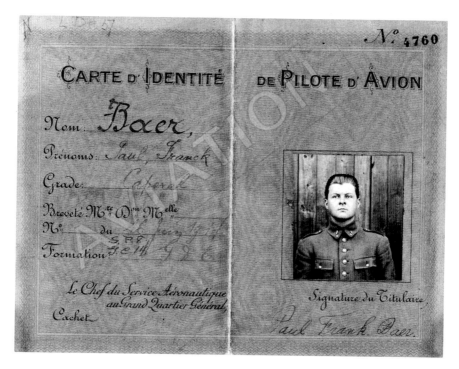

Baer was commissioned in June 1917 and earned his French pilot ID card. *Paul Baer Collection, Allen County–Fort Wayne Historical Society.*

also added time to his log book by practicing group and formation flying while familiarizing himself with the variety and peculiarities of French aircraft, including the newer SPAD fighter, which had been appearing in greater numbers.[50]

As Paul Baer completed his flight training in August 1917, the harrowing events faced by the infantry in the trenches appeared to have no end in sight. For those soldiers deemed to serve on the ground, one can only begin to imagine how they wished to be lifted into the air and away from the grisly nightmare:

They [the infantrymen] *were witnesses to the turning of an age. Still unaccustomed to the sputtering roar of an airplane engine overhead, the French cavalrymen…couldn't have known how profoundly their world would be changed by flying machines. Even though aircraft would have relatively minor impact on the horrific fighting in the trenches and the war's*

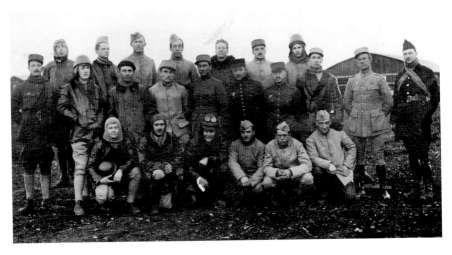

Baer (*front row, far left*) and fellow pilot candidates at Avord. *Paul Baer Collection, Allen County–Fort Wayne Historical Society.*

final outcome, the airplane's potential in combat—as reconnaissance craft, bomber, and fighter—was already proving itself.[51]

Baer wasn't the only member of his family to serve during World War I. Both his older brother, Arthur, and younger brother, Buddy, also got into the action: "Baer has two brothers in the service of their country. Arthur Baer is a quartermaster [an officer responsible for providing quarters, rations, clothing and supplies] aboard a cruiser [the USS *Charleston*] and A.W. (Bud) Baer is in the gun sighting department at a navy yard. The latter has also had two years' service on one of Uncle Sam's submarines."[52]

According to their registration cards, both Arthur and Bud held the rank of petty officer in the U.S. Navy; Bud served as a machinist at the navy yard in Washington, D.C. Like their brother Paul, both survived the war.[53]

Meanwhile, Paul Baer waited at the *Groupe des Divisions d'Entrainment* for his orders to arrive. The wait would not last long.[54]

CHAPTER 3

"I SPEARED ANOTHER HUN"

I t is unknown whether Baer ever met Louis Bleriot, the pioneering
French aircraft designer and pilot. Yet it was the product of Bleriot's
company that gave Baer his wings to fight the enemy.

In 1914, Bleriot was named president of the struggling aircraft
manufacturer *Société Pour les Appareils Deperdussin*. In one of his first actions
after taking over, Bleriot renamed the company *Société Pour Aviation et ses
Derives* (SPAD). The abbreviation became the name of the sturdy fighter in
which Baer would earn his victories. Under Bleriot's leadership, the SPAD
company became one of France's foremost manufacturers of fighter aircraft.
More than 5,600 Spad fighters were built during World War I for France,
Great Britain and other countries.[55]

Caporal Baer began flying with *Escadrille SPA 80* on August 14, 1917, joining
fellow American pilots C.J. Coatsworth, Walter Rheno and Charles H.
Wilcox. During the summer of 1917, the four had many thrilling adventures
over the Verdun Sector (about 140 miles east of Paris). What Baer didn't
have was his first kill. Wilcox and Baer had trained together in flying school
and shared similarities, including a joint disappointment over the lack of a
first victory:

> *Both were keen pilots, eager to get results. Both did their work well, taking
> much more than their allotted share of patrol duty for the sake of the
> experience which it brought; and for more than six months both fought
> battles without the fine incentive which an actual verified success brings*

to a pilot. Americans who met them occasionally at Bar-le-Duc, the old rendezvous for airmen on the Verdun Front, will remember their disgust at their ill-fortune. All of the Germans they attacked carried sky-hooks (i.e., as if some invisible cable kept them in the air). They declined to fall even though riddled with bullets. Their motors were armor-plated and their gas tanks indestructible, in so far as the experience of Pilots Wilcox and Baer were concerned.[56]

Meanwhile, on November 5, Baer was commissioned a first lieutenant in the Aviation Section Signal Corps and then transferred on January 10, 1918, to *Escadrille SPA 124*. American William Thaw was the commanding officer, and they "had good Spads and plenty of them. Beside the regular daily patrols there were many voluntary ones, for every pilot was eager to secure the first official victory."[57]

SPA 124 pilots flew two versions of the Spad.[58] Each had its strengths and weaknesses. In a letter written to a friend, Baer noted, "[W]e fly Spads of two types, the 180 h.p. and the 220 h.p. The 220 carries two of the Vickers machine guns, but the motors do not hold up very good…you can never depend on them. We therefore prefer the 180's. It carries only one machine gun. I was in the French Escadrille until January 6 (18) when I joined the Lafayette Escadrille."[59]

On February 18, 1918, "under the provisions of a curious and interesting agreement between the French and American armies," *SPA 124* evolved into the 103d Pursuit Squadron of the U.S. Air Service. There was just one catch, as detailed in a 1966 letter written by Royal D. Frey, a United States Air Force historian. Frey explained that *SPA 124* indeed was transferred to the U.S. Air Service and became the 103d Aero Squadron. However, "*the squadron remained under the control of the French Air Service for several months*, even though it was now a U.S. unit, and it flew combat *on the French Front.*"[60]

So, despite being a member of the 103d Aero Squadron, Baer was still operating under the command of the French Air Service over French battlefields as his combat missions continued. The squadron was assigned to the 15th Combat Group and then to the 21st Combat Group with the 4th French Army from February 18 to April 9, 1918. From April 10 to April 30, the unit reported to the 6th French Army and from May 1 to June 30 to the French DAN. It wasn't until July that the squadron began its service as an American unit. As Baer put it in a letter, "I have been flying in several parts of the front over here, in fact, the whole western

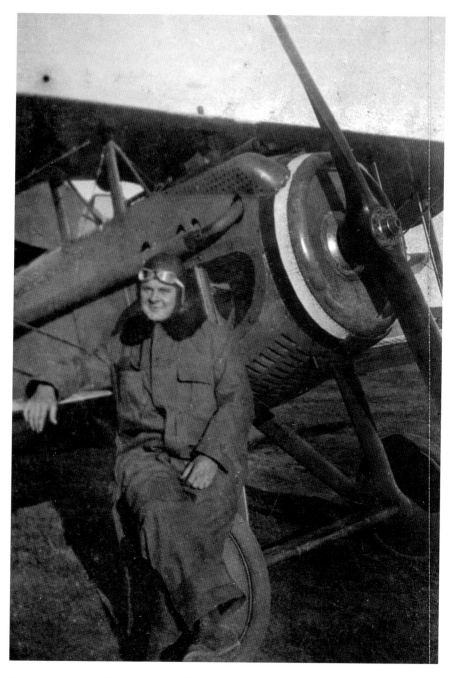

Baer, now a fighter pilot, with his Spad in August 1917, stationed at Verdun. *Paul Baer Collection, Allen County–Fort Wayne Historical Society.*

front as we are not assigned to any army and therefore move about all the time."[61] All that flying was about to pay off.

Baer achieved his first victory on March 11, 1918, shooting down a German Albatross fighter near Rheims. It was the first German aircraft to be downed by a U.S. officer. Back in the States, the Associated Press described the reaction of Baer's sister, Mabel, upon hearing the news:

"Thanks so much," Mrs. Arthur Armstrong, the young aviator's sister, said when informed of her brother's feat. "Mother will be so proud of him, when she hears. She's here in Fort Wayne now but there's no telephone where she is on Fox avenue, but I'm going to find her right away to tell her what Paul did. He was in Paris the last word we had from him. You're real sure he wasn't hurt at all?" she inquired anxiously. When reassured on that score she said, "Oh, that's just wonderful, to think that Paul went for them that way and brought one of them down."[62]

Baer's next three victories were tallied on March 16, April 6 and April 12. After the victory on April 12, he wrote the following letter to his mother:

Dear Mother: Just a few lines tonight. I am getting along fine. We are in a new sector now—in the fight. How are you getting along? I hope all right. I am enclosing copies of my second and third German machines to my credit. I now have four "official," my last being on April 12, which I also brought down in flames. That is three in flames and one which did not go down in flames. General Louvaud of the Fourth French Army stuck a Croix de Guerre on me with some palms. A palm is the highest citation. He also gave me a pipe. He lost an arm and a leg in this war. He is a fine old chap, too. We have another general now, as we are with another army. Goodbye and good luck. Paul.[63]

On Friday, April 23, 1918, Baer shot down his fifth Hun plane, making him the first American pilot ever to become a combat ace…or was he? While Baer was tallying his victories, the 94th Aero Squadron of the U.S. Air Service began flying combat patrols in April 1918 from the city of Toul in northeastern France. The pilots patrolled the American front lines in an area that stretched from St. Mihiel eastward to Pont-a-Mousson. Lieutenant Douglas Campbell of the 94th scored his first victory on April 14 and his fifth on May 31. In a 1966 letter, Frey noted the reason Baer's accomplishment went unnoticed:

As a member of this unit, Lt. Douglas Campbell became the first U.S. pilot to be awarded confirmation for destroying five enemy aircraft over the American Front. Unfortunately, few men in the Toul area knew of the 103d [Baer's squadron] and the fact it had been flying with the French for several months a hundred or so miles to the northwest, and Lt. Baer's accomplishments went unnoticed by the war correspondents at Toul. Consequently when Campbell got his 5th victory, he was hailed by the press as the first U.S. ace. Despite all these "circumstances," Baer was definitely the first U.S. Air Service pilot to become an ace in World War I.[64]

In April 1918, Baer's father received a letter from his son postmarked March 13, two days after his first victory—and his father's birthday. In the letter, Baer described being outnumbered during a fight with seven German aircraft:

Dear Dad:

If I remember right, today is your birthday. I will write you a letter. The last few days here have been wonderful—just like summer. I suppose you are having some pretty weather also. March during the whole month was terrible. Well, Dad, at last I got my first "official" German aeroplane. Day before yesterday [March 11, 6:00 p.m.], *I, unaccompanied, was flying inside the German lines. As time drew near for me to come home, as I had been out my full time, and while almost at our lines, the French send up a signal to me which told me in what sector the Boche were. I turned around and was greeted by seven German planes. Part of the enemy machines were above me and part of them below. Well, I only had enough gasoline for ten minutes more flight, and I was six or eight kilometers inside their lines. I pointed my machine at the closest one to me, and as soon as I got right on him, I opened up with my machine gun and down he went. The rest of them came at me at the same time and I sure did some "scientific retreating." Well, the Hun I killed is official, that is I got credit for killing him. He fell about seven kilometers in his own lines, but the French saw him hit the ground. The next morning, March 12, at 9:25 o'clock, I speared another Hun. It was in about the same place as the first one I killed. He was about ten kilometers within his lines when he fell. I saw him crash into the ground. He was one of a patrol of five Boche. Again I had to do some "scientific retreating." I had all of them on me. Their bullets were flying all around me. However, I got home. The second one is not yet*

official. I do not know if it will be, but hope so. I really have four Germans
that I have bagged in the air, but credit for only one so far. I have had five
combats in the last ten days, with three bullets in my machine. But I shot
down two Germans and perhaps another one not yet confirmed.[65]

Despite growing experience and strengthening skills, the duels in the air remained treacherously dangerous for Baer, with little room for error. Later in the morning on March 12, Baer took off again with fellow pilots Robert Rockwell of Ohio, Phelps Collins of Michigan and James Norman Hall of Iowa, who would later coauthor *Mutiny on the Bounty*. Baer described what happened as they responded to a report of three enemy aircraft sighted in their vicinity:

While Rockwell, Hall and Collins and myself were patrolling in the region
of Paris yesterday, being in search of three Boche planes that were over Paris
at 10:50 a.m., I had motor trouble and had to land in a place near Chateau
Thiery [sic]. Collins was killed. We as yet have no details. We are of the
opinion that his machine broke in the air. We are sure there was no German
plane near him. We will know today, as we are going after his body.[66]

But another factor may have claimed Collins's life. He had a reputation as a tireless pilot who worked feverishly from the first day of his assignment on February 18 to the 103d Aero Squadron to the day of his death. One theory is that fatigue overcame him and he passed out while in the air, crashing to his death during the patrol with Baer and the others eight kilometers south of Charly-sur-Marne, about fifty miles east of Paris.[67]

In May, Baer tallied four more victories, including his ninth official kill on May 22. But his remaining time in the air was running short.

For the 227 total hours logged fighting over the front, Lieutenant Paul Frank Baer would receive numerous honors, including more than twenty awards and citations. These included the Legion of Honor and *Croix de Guerre* (Cross of War) with seven palms—the highest award bestowed by France on non-citizens fighting with the French military.[68] Made of bronze in the shape of a large Maltese cross with crossed swords, the medal was conferred on members of the French military named in army dispatches for extraordinary feats, with the number of palms representing the number of dispatches. Baer also was the first aviator to receive the U.S. Distinguished Service Cross (DSC) with bronze oak leaf cluster, shortly after it had been established by order of President Woodrow Wilson in April 1917.[69] Baer

received one for each of his victories on March 11 and 16. The cluster, comprising four oak leaves and three acorns, represents Baer's second DSC, awarded for the March 16 victory. The DSC is the second-highest military award after the Medal of Honor. Baer's first citation, issued April 12, 1918, read as follows:

> *1ˢᵗ Lt. Paul Frank Baer, Aviation Section, Signal Corps, distinguished himself by extraordinary heroism in connection with military operations against an armed enemy of the United States at Rheims, France, on March 11, 1918, and in recognition of his gallant conduct, I have awarded him in the name of the president the Distinguished Service Cross. Signed, John J. Pershing, Commander-in-Chief, United States Army.*

The Aero Club of America, an organization of aviation enthusiasts dedicated to promoting flying in America, awarded Baer its Medal of Honor. The humble lieutenant, whether he liked it or not, would continue to receive other praise. In his memoirs, *Fighting the Flying Circus*, Captain Edward V. Rickenbacker, commander of the 94ᵗʰ Aero Squadron, fighter ace and Medal of Honor winner, spoke fondly of Baer's contributions:

> *Upon the tragic death of Major [Raoul] Lufbery, who at the time was the leading American Ace with 18 victories, the title of American Ace of Aces fell to Paul Frank Baer of Fort Wayne, Ind., a member of the Lafayette Escadrille 103. Baer then had nine victories and had never been wounded. Baer is a particularly modest and lovable boy, and curiously enough is one of the few fighting pilots I have met who felt a real repugnance in his task of shooting down enemy aviators. When Lufbery fell, Baer's Commanding Officer, Major William Thaw, called him into the office and talked seriously with him regarding the opportunity before him as America's leading ace. He advised Baer to be cautious and he would go far.*[70]

How far Lieutenant Paul Baer would go would be resolved in a matter of days.

CHAPTER 4

SHOT DOWN!

B aer was now twenty-two years old with nine victories earned in the skies over Europe. His reputation among his fellow fighter pilots continued to draw admiration and praise. He journeyed to Europe to sign up and fight long before the United States declared war against Germany, and his adventurous spirit was welcomed and embraced by similarly constituted volunteers. If asked, many of them would have wagered that the Indiana native stood to score a long string of victories against the enemy:

He has all the qualities of an Ace: the coolness, the skill, the endurance, and the courage. Always on the offensive, Baer cruised far within the enemy lines in search of the enemy, and never hesitated to attack against heavy odds or under unfavorable circumstances. During the few months he was at the Front, he was…winning the reputation of a fighting pilot of the first order. His keenness and endurance are shown by the fact that in one day he has been known to make six patrols over the lines—a truly remarkable feat, as every aviator knows. Baer's resistance to fatigue is undoubtedly due to his simple habits. He took excellent care of his health and kept himself in all-round training like an athlete. He is, however, a thoroughly companionable fellow, always ready for a good time, frank and unaffected in manner, and much loved by his comrades.[71]

His keenness and endurance were about to face the supreme test. At 9:00 a.m. on Wednesday, May 22, Baer led a patrol comprising Lieutenants Ernest A. Giroux, George Turnure, Charles Wilcox and William Dugan Jr. The patrol headed over enemy lines about ten miles southwest of the city of Armentieres. Flying at sixteen thousand feet, they spotted five German single-seat fighters below and ahead—well into the enemy territory. As Baer's flight dove to attack, a surprise appeared from above:

> *They saw three other German machines above them. Baer, with Giroux close behind him, plunged headlong on one of the lower machines; next moment, the other four enemies dove on the two attackers. The three Germans of the big patrol piqued at once into the melee, and a fast and bitter combat ensued, during which Giroux was brought down and killed, and Baer had his controls cut by a bullet, after bringing down a German in flames. The other three Americans, heavily outnumbered and caught in a tight place, disengaged themselves with difficulty and reported on landing at the Squadron that, when last seen, Baer was descending normally and was probably a prisoner.*[72]

In fact, the control wires in Baer's Spad had been severed by enemy bullets. Two German Albatross fighters stuck to his tail, spraying their bullets at him as he plummeted to the earth below. Baer's Spad S.XIII fell earthward more than thirteen thousand feet, hurtling to the ground, where he crashed and "escaped only by a miracle."[73] He later wrote in a letter from prison that "he was spared serious injury as the result of his plane first hitting a tree before falling to the ground. He received injuries to his legs and 'was black and blue all over.'"[74]

Not surprisingly, whenever Baer was asked about his time in prison, he was characteristically reluctant to offer details. Those details he did share were vague in nature. In fact, his injuries sustained in the crash required seven days in the hospital. He spent time in several German prisons, including at Moewe and later Graudenz,[75] where he was "the only Yank among almost 600 British."

In the beginning of his captivity, he was generally treated well at the headquarters of Jasta 18 (Jasta is an abbreviation for the German word meaning squadron), the unit that ended his flying days. But demons awaited him in the days to follow—almost as dangerous as the combat flying he so fortuitously survived:

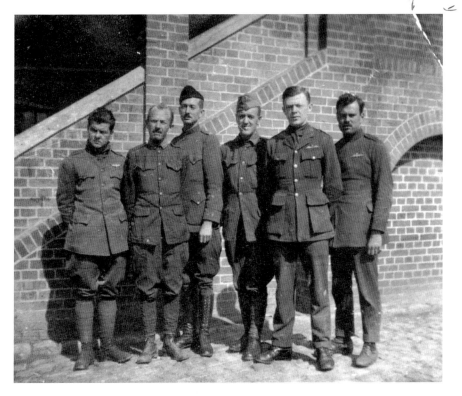

Fellow inmates pose with Baer at a German prison. *Paul Baer Collection, Allen County–Fort Wayne Historical Society.*

While being taken to the rear to receive treatment for his knee (which had been broken in the crash), he was noticed by a German infantry officer of very forbidding aspect. Frowning heavily, he approached the wounded American and, pointing to the ribbon of his Croix de Guerre, asked the meaning of the palms attached. Baer shook his head, not understanding at first, but another German standing near by said, "Each one of those Palms represents a Deutscher Flieger shot down." At this announcement the German, forgetting all tenets of military courtesy, reached over and pulled the decoration from Baer's breast with such violence that the pin ripped a hole in his tunic.[76]

A willing prisoner Baer was not. He attempted to escape, despite being hobbled by his injured knee, and fled into northern Germany. He enjoyed freedom for a few days, but it came at a cost:

*After several days of exposure and fatigue, he was captured by a body
of the lowest type of German soldiers, and taken, in company with two
escaped British officers, into a cellar where the soldiers were carousing with
a number of women. In this place Baer, crippled and half dead with
fatigue, was singled out for the heavy gibes and insults of his captors, and
at last, unable to resist, was so severely beaten and mauled that he considers
himself lucky to have escaped with his life.*[77]

Meanwhile, back in the States, news of Paul's capture slowly began to
emerge. In May, newspaper articles reported ominous news: "Lieutenant
Paul F. Baer of Fort Wayne, Ind., an aviator, is posted as missing since May
22. It is hoped he is alive, as he may have been taken prisoner."[78] In early
summer, Baer's fate was confirmed by the U.S. government: "Lieut. Paul
Frank Baer, the American Ace, is a prisoner in a German camp, according
to telegrams received here [Fort Wayne] today by the aviator's mother
from the War Department."[79] In July, a cablegram notified Baer's mother
that Paul had been identified in the German prison camp of Graudenz,
located in Prussia.

In August, Mrs. Baer received the first direct word from her son—a letter
whose content would startle any mother:

*"Please send me food packages through the Red Cross at Berne, Switzerland.
I must have them. Send malted milk tablets and chocolate. Also send me
some underclothes and other clothing. I have not been receiving a package
since being taken prisoner." This is part of a message contained in a letter
received this morning by Mrs. Emma Baer Dyer, 1304 Maud street, from
her son, Lieutenant Paul Baer, now in a prison camp, at Gradenz [sic],
West Prussia. She had heard through the Red Cross that he had been
captured and Lieutenant Wilcox who was in his flight squadron reported
that he saw Lieutenant Baer forced to descend behind the German lines.
Whether he is receiving good treatment or not is not stated in the letter, but
his appeal for food indicates that the prisoners are not receiving enough to
eat, and have not sufficient clothing. Mrs. Dyer immediately sent some food
today and will send clothing. She will take up with the Red Cross the matter
of sending parcels of food to him at regular intervals.*[80]

Although Baer attempted to send letters to his mother, the Germans were
agonizingly slow in actually processing the correspondence. For example,
on September 5, 1918, Emma received a letter dated May 28—delayed

more than three months. It offered more details about his injuries and the circumstances of his being shot down:

Dear Mother:

I made my last flight on the 22nd of May, when I was brought down by three enemy machines. I have a couple slight wounds on my left knee. My machine was riddled with bullets, and bullets in my motor caused it to stop. I went thru [sic] a tree and crashed into the ground smashing my machine to bits. I have bruises and black & blue marks all over but am getting along all right. I am now in a hospital. When thru here, I will probably go to a British Aviators' Prison Camp, somewhere in Southern Germany. Hope you are getting along all right and continue. The next bed to me is occupied by an English Colonel who was shot in the hip and next to the Colonel is an American Army Doctor (captured with the British, he was shot thru the ankle). As I have no news to tell you from now on as I am a prisoner, I shall close and write soon. From Lt. Paul F. Baer, Aviator, Stammlager, Limborg a.d. Lahn, Germany. Address me as above and it will be forwarded on to me wherever I am. So good-bye and good luck.

Paul[81]

Baer's mother also received a response from the American Red Cross regarding her concern that Paul was not receiving his care packages. The letter was printed in a local newspaper:

Dear Madam: We have your letter of August 31, 1918, with reference to your son, Lieut. Paul F. Baer, now located at Camp Graudenz, Germany. We have today received a cable from the American Red Cross at Berne Switzerland, stating that they have your son recorded upon their lists as at Camp Graudenz. This shows that the Red Cross headquarters is in communication with him, and that he is now receiving the regular supplies sent to all American prisoners of war, such as a twenty-pound parcel of well selected food, semi-weekly, clothing when required, and such comforts as mending kits, shaving and toilet soap, chocolate, safety razors, tobacco, jam, etc. We are enclosing a list of the foods sent semi-weekly, and a list of the clothing which our prisoners receive. (The outfits comprise the following: Flannel shirts, undershirts, drawers, trousers, coats, overcoats, shoes, caps, leggings, socks, coat buttons, huckaback towels [i.e., an extremely

absorbent towel], *hair brushes, shaving brushes…handkerchiefs, shaving soap, tooth brushes, combs, pencils, tooth powder, dry pipe lighters). We advise you not to worry, as he is located in a camp where there are many British officers, and certainly they would not permit him to want for anything. However, we do understand how you feel about his being associated with Americans in an American camp, and shall do our utmost to secure his transfer.*[82]

It was signed by L. Halstead of the Red Cross Bureau of Prisoners' Relief. The newspaper article noted that the letter brought "indescribable relief to the mother, for it tells her that her son is being cared for by the Red Cross."

In another example, "a letter written Oct. 5, 1918 from Graudenz, mailed by the Germans on Oct. 19, was the first direct word Paul's mother received after his capture. It fared better than the first letter he wrote on Sept. 28, which was not mailed until Nov. 15."[83]

While her son was imprisoned, Emma received several letters from Major Thaw, Baer's commanding officer. Thaw was particularly effusive in his praise of Baer, noting her son's courage, extraordinary skill and cunning tactics he used in combat. In one letter, Thaw informed Baer's mother that he had been officially credited with nine enemy planes and had actually destroyed or shot down a total of seventeen. Emma told a reporter that Major Thaw's words provided relief to a worry-stricken mother:

"I am the happiest woman in the world," said Mrs. Dyer last night. "I only wish that every mother with a boy over there could feel as I do now. The relief to know that he is safe and well, and that he was not killed is as great a happiness as I find in these letters commending him, and the fact that he has been given another award. I suppose he will be coming home soon, and then my happiness will be complete. I am indeed proud to have for a son a man who has served his country so well."[84]

The Red Cross care packages, and those parcels Emma sent every month, finally reached Paul after some delay. This was confirmed in a letter dated October 5 that reached Baer's mother some weeks later: "Dear Mother: I sent you a card a few days ago in answer to a letter from the Red Cross at Berne, Switzerland, saying you had not heard from me. I have written to you several times. I am now getting my American Red Cross parcels; they have been coming for one month now."

Reluctant as he was to disclose the details of his captivity, Baer later provided a glimpse into his time in captivity for a hometown newspaper:

Of his prison experiences, Lieutenant Baer declined to go into details. He was in several prisons and was practically alone so far as his countrymen were concerned, for there was not another American included in the guests who were being "boarded" as tourists in the fatherland who believed that the world could no longer exist without the blessings of Prussianism. All that the officer would say last night relative to the experiences in German prisons was "as a prisoner of war I was treated all right. I didn't expect much anyway and so was prepared for anything. The officers did not have to work. There were upwards of 500 British officers in the prison I was in, in the lower part of Germany." When asked how they spent their time, Lieutenant Baer stated that there were many ways to keep the time from dragging too wearily. Although closely confined and guarded constantly, they had various forms of amusement, with access to many good books and reading matter. Then there were entertainments, debates and the like, and once in a while mail would arrive from home.[85]

According to the story, Baer had "a chuckle over the remembrance of one prison experience":

Lieutenant Baer told of the standing joke they had over the alleged beverage which was served by their German captors and which the disciples of kultur called coffee. The stuff never was introduced to coffee and did not have a speaking acquaintance with chickory. It was a mixture of some sort of acorns and burned grain. When this was brought in, some of the prisoners would remark: "Well boys, it's time to shave. Here comes the hot water." And as a matter of fact that's all the stuff was good for.[86]

Despite putting the best face on imprisonment, the hours dragged, and days and weeks passed with dim hope of a release from captivity. Summer turned to autumn and then to fall, with winter not far behind. There was little news about the war. "The few German newspapers available, of course, covered up the truth and none of the men in prison knew that the Huns had been sent back in defeat. At length there came a day when the occupants of the prison were electrified by the news of peace and victory."[87]

The Allies defeated Germany in November 1918, and Baer's freedom finally arrived. He was released from prison on November 29, 1918,

eighteen days after the Armistice was signed. On December 11, Emma received a cable confirming that her son had been freed, and a hometown newspaper reported his liberation: "Lieut. Paul Baer, Fort Wayne's ace has been released from the German prison at Graudenz, Prussia and has landed at Leith, Scotland," after sailing from Copenhagen. He was reported in good health.[88]

Baer arrived in New York on January 31, 1919, after crossing the Atlantic on the USS *Adriatic*. With him on the ocean crossing were such famous fighter aces as Eddie Rickenbacker and Douglas Campbell.[89] He initially settled in Washington, D.C. On February 1, his mother received a letter from Ensign Carlisle S. Baer (no relation) stating that a box with her son's medals and personal belongings had just been discovered and would be forwarded to her at once.

Grateful citizens were anxious to turn the spotlight on their returning heroes. More than six hundred people attended a reception and dinner in New York on February 4 honoring America's aces, including Baer, Captain Eddie Rickenbacker and Captain Douglas Campbell. "Messages from General [John] Pershing and [former president] William Howard Taft commending the great service of the American aces were read by Secretary of War [Newton] Baker" at the banquet.[90]

In the coming days, word got out that Baer planned to travel to Fort Wayne. His mother tried to set realistic expectations about her son for the local newspaper reporters, telling them, "Paul is averse to any display or extraordinary attention, and to this end he donned civilian clothing while in Washington, where he was made the center of much ado." In reporting this, one newspaper evidently felt compelled to justify the Rotary Club's attempt to honor Baer:

> *The privilege of seeing the young man who has made such a proud name and to give him the assurance of the appreciation of his friends at home, is all that the club may wish. Then, to arrange for a public reception which all may attend, gives everyone an opportunity which is doubly welcome because of the fact that the young aviator will probably be in the city only two days before going to New York.*[91]

On his way back to Indiana, Baer stopped in Detroit to pick up his friend Lieutenant Harry Runser, a "doughboy" (a nickname given to World War I infantrymen possibly based on their method of cooking rations with a doughy flour).[92] When a reporter caught up with him and appealed for a

message that could be given to the citizens of Fort Wayne, Baer was reluctant and "modest to a fault":

He at first positively refused to be interviewed saying that since coming to America he had carefully kept away from any publicity, and that he had done no more than the others were willing to do in order to win the war. "Never mind me. Just praise the American doughboy as he fought in the trenches. You can't say enough about him. They are the boys who experienced the hardships and the real sufferings of the war. We did nothing when compared with what they endured. I don't want the people to go to a lot of expense on my account. I know how they feel about it and suppose I ought to feel proud, but honestly I wish they would save all this reception and banquet for the boys who really deserve it. They'll be home some day and then you can't do too much for them."[93]

Baer and Runser completed the 160-mile journey from Detroit to Fort Wayne on the Wabash Railroad. They arrived in Fort Wayne around 9:00 p.m., Wednesday, February 27, 1919. Since no one in Fort Wayne knew the exact time of their arrival, there were no crowds awaiting to greet them at the station—no doubt a relief to the publicity-shy Baer. Runser stayed at Emma's house as her guest.

In Fort Wayne, everyone was searching for ways to pay tribute to Baer, whether he wanted it or not. An opinion piece in a local newspaper found a way to praise Baer for his convictions and dedication as a volunteer by weaving it into a swipe at President Woodrow Wilson, members of Congress and the Washington establishment, blasting them for America's delayed entry into World War I:

Incidentally Paul Baer left Fort Wayne to fight for the allies just about the time that President Wilson declared that we were "too proud to fight." [Baer] had a clearer vision of the situation and its needs than had those in power in Washington, and in going to the support of the cause, he rather shamed his government. Thousands of other young Americans did likewise and while Paul Baer attained a distinction that fell to the lot of but few and rendered a service not all were qualified to render, he no doubt is satisfied to share only in the glory that inures to that small army that went from the states to fight while the Washington administration passed out platitudes concerning peace and prosperity.[94]

Lieutenant Baer's fighting days soaring over France in search of enemy fliers and the life-and-death struggles that followed had come to an end. But it would take another decade before the full story of his last flight and imprisonment would come to light.

A Caged Birdman

T rue to his reticent nature, Baer rarely spoke in detail while he was alive about the day he was shot down or about the months he spent in captivity. When he could not find a reason to excuse his attendance at events organized in his honor, he occasionally offered limited glimpses into that particular period if only to quiet the desperate pleas from hosts begging him to offer a few words for attendees.

A full accounting in his own words only emerged thirteen years after his ordeal, and only after Baer mercifully reached a quiet place where he was safe from spotlights and the pressure of public attention he so dreaded: his grave. On May 20, 1931, nearly five months after his death in a flying accident in China, a Fort Wayne newspaper published excerpts from a letter Baer had written "to a chum following the war."[95] The ten-page typewritten letter,[96] which the newspaper obtained from Emma, provided a firsthand account of the battle that ended Baer's flying days and the struggles he faced thereafter.

> *My thoughts on the morning of May 22nd, 1918, as I lay in bed, were that I undoubtedly would have very good luck, and figured that I should get in at least six hours over the lines, which should certainly net me some Germans. The first patrol was scheduled for 8-45 A.M. with myself as leader. As the time came for soaring aloft I was feeling quite confident that if we should meet enemy machines, we would be successful, for with me were three experienced pilots, and one who was comparatively new, although*

quite eager. We were soon in formation and headed for Ypres. The sky was wonderfully clear, not a cloud to be seen. Everything seemed so beautiful and serene that one would not think that a terrible war was going on beneath us. We were flying in this region hoping to see some of the Kaisers [sic] aircraft, but no enemy machines were seen, we therefore headed into the German lines. Our patrol was flying at an altitude of 4300 metres and in good formation for a combat with the Huns, and all were quite confident that if we did meet them, we would certainly increase our record of enemy machines brought down. It seemed however that this morning, of all mornings, was too peaceful and beautiful for mortal combats to be fought above the clouds. We were now several kilometers within the enemy lines, and it seemed strange that we should not see German machines up before this. However in a few seconds we could see several specks further into their own lines—they evidently were just leaving their Aerodrome for the lines. As we neared the specks and they became larger we could readily see that they were German machines and that we were in for a fight. They were eight in number and flying a little above us, which gave them a decided advantage over us, in having both the best position and more machines than we had.

We immediately began to climb, hoping to get at least as high or higher before hostilities began. In that we were not successful but, we figured that by keeping in close formation we would have a good chance of holding our own with them. Upon nearing the machines they were readily discerned as Albatross machines, each mounting two machine-guns, while we carried one on our machines. The Huns opened fire first, shooting wildly from too great a distance to shoot accurately but, luck was with them however, as I felt my propeller receiving their bullets and begin to split up, causing my machine to vibrate very seriously, my wings too were receiving their share of bullets making them look like a tea strainer. On account of the Germans all being above it was very difficult for me to maneuver out of their range of fire. In trying to maneuver for a better position I noticed that one of my comrades was being attacked by two Germans, and I immediately endeavored to help him. I succeeded in ending the career of another German but, too late to save the career of my comrade who fell to his death from a height of about 15,000 feet.

At this time I noticed another German a little distance away, and headed in his direction, but I had not gone far when an anti-aircraft shell hit my left lower wing, and almost immediately I was attacked from the rear by the first group of Germans and the next few seconds found me with my controls shot away and my machine began falling into the German lines,

from an altitude of about 12,000 feet. My descent was probably very short but to me it seemed hours. I of course thought of a pleasant smash etc. and was still thinking when my machine fell into a tree, that being the last I remembered for some hours afterward. When later I came to my senses I found myself in a German hospital all bandaged up, and then I commenced wondering how badly I was hurt.

Being very badly cut and bruised all over my body the German doctor painted me all over with iodine, and wrapped me up in paper bandages. My legs were in splints wrapped in wet paper and cloth. I was the only prisoner in the ward, the others were all seriously wounded Germans. They gave me a cot on what was formerly the stage of a gymnasium. The food that I received was black bread with a small quantity of terrible beet jam, and a very light soup. The laboring was performed by French women prisoners who were required to work from ten to fifteen hours a day. They soon transferred me from this hospital at Tourcon, which was near Lille, to another hospital at Ghent, Belgium. At Ghent, they put me in a ward that contained an American doctor who was captured with the British and several Frenchmen, Britishers, Italians, Russians, and Belgians. My treatment here was a little better than before, as was the food. There were several German Red Cross nurses at this hospital, however they seldom would serve me—generally remarking that I was an aviator and dropped bombs on them. My stay at this place was not very long however as soon after that I was given a few minutes notice that a train would leave in the afternoon for Dansig, which is about four days trip from Ghent.

I was a stretcher case however and that fortunately would not make the trip so tiresome, as a great many had to set up all the way. This hospital train did not miss a single station all the way across Germany no matter how small the village. Three days later I was taken off the train at Czersk, West Prussia, which is on the old Polish frontier. In this camp were prisoners of all countries. I being the first and only American. I shall not describe my experiences up to now, as with the exception of being very dull there is little to say. Here I had long talks with several British prisoners who were captured in the first month of the war, whose experiences working on parties sent up in Russia were both so sad and tragic that but few lived to tell of their hardships. For some reason which I cannot explain the commandant of this camp sent me to a Russian prisoners camp instead of an American or British camp. This camp contained 300 Russians and myself. At this time it was very difficult

51

for me to walk and it was quite painful, however that did not prevent the Huns from putting me on the fifth floor (Top). I shared a room with six Russians, the room being about large enough for two.

Upon arriving at this camp I was very hungry. One Russian gave me some beans, another a piece of bread, so I sat down to eat. Then a Russian very kindly gave me a bottle of what I thought was soda water. I finished the bottle and it seemed good, with the exception of being too sweet. The following day, I was quite sick, and a Russian asked me what was the trouble. I told him that the soda water was the reason. He then informed me it was not soda water, but a liquid used instead of sugar and fifty times sweeter. One teaspoonful in a cup of coffee making it quite sweet. The bottle was quite expensive, but being very sick probably compensated him for his kindness. The building we occupied was built in the year 1295 as a Knight's Castle, and later turned into a prison (Civilian). The food was not good, of course, neither was there much of it, but some of the Russians had a few gardens containing onions, radishes, a few strawberries and potatoes. The Russians were all good natured and apparently happy. A few of them quite contented to be prisoners and others were very sorry that Russia dropped out of the war. After spending two weeks in this camp, I was transferred to a British prisoner's camp at Graudenz, West Prussia, on the Vistula River.

Graudenz has a population of 60,000 inhabitants and is a very pretty town, with several historic pieces of interest. It has an aviation school and is a permanent military post with an immense number of fine barracks, some of which were occupied by French and British prisoners. In the British camp were about 650 officers and 100 enlisted men. There were four American officers, three doctors who were attached to the British and myself. We occupied two large buildings (4 stories) and were fortunate to have a large compound for walking and games. The senior British officer was a brigadier-general, the whole camp being commanded by a German major, with a large staff under him.

As the camp was only a few weeks old we lived or (merely existed) on the German food, which consisted of very light soup and potatoes and bad fish and probably a few carrots, very little of each. Until the time Red Cross parcels began coming, it was about all one could do to walk, and very difficult to walk up a flight of steps. With the coming of the food parcels, the camp was changed apparently to a new life. Sports were organized, and educational classes were formed in languages, mathematics, bookkeeping, etc. A good library was at hand and later a

camp newspaper was included. A theater was built by the prisoners, and regular shows were staged from talent among the men, which included a first class orchestra.

While these things were being developed, others were thinking of escaping. An escape committee was thereby formed with a South African colonel at the head. From the different suggestions offered him, it was decided that a tunnel was the most feasible plan for escaping. We were surrounded on all sides by two high fences, one being a brick wall and the other a barbed-wire fence. There were stationed, sentries on the inside of the fences, and also on the outside, which rendered escape practically impossible, at least to the German mind. At night the fences were lighted.

After investigating the basement of the building, it was decided to tunnel thru from building number 2. By making a barrage of several fellows in front of the basement window while others engaged the attention of the Germans somewhere else, either by conversation, or pre-arranged arguments, etc., it was possible for the workers to drop down into the basement. The tunneling was carried out in shifts of two, three and sometimes four men, each shift working from two to three hours. Then a set of signals were made thru which it was possible to warn the tunnelers at times of danger when to come out. When changing shifts a number of men would congregate in front of the window etc., while the men came out. The work was doubly dangerous, because first if caught, they would place very severe restrictions on the whole camp, and the men caught were not only required to pay immense damages to the building, etc., but were liable to six months punishment in a military prison.

The work of digging the tunnel was a very difficult undertaking. In the first place the men had no suitable tools to work with, for an ordinary tunnel. But here they had also two very thick stone and brick walls to go thru. It was therefore quite necessary to make no noise while digging the tunnels, as sentries were right over their heads, but another difficult part of the work was to find a suitable place to hide the dirt and sand, and to leave no traces, as Germans came thru the basement every day.

Fortunately there was a great deal of wooden beds, chairs, racks of every description, etc., in the basement and a place was found to hide the dirt where upon an ordinary investigation the Germans would not be liable to see the refuse. For the sand and waste from the tunnel, a place under some steps was used. The length of the tunnel was about 40 feet, and with the exception of the walls the work was comparatively easy. The work was supervised by an engineer experienced in tunneling. The lining of the tunnel

was made from boards from the men's beds and the tunnel required a great many, which later resulted in an amusing incident.

As the days went on and work on the tunnel continued, the men were in high hopes of making a successful escape, and were preparing their packs for the trip which included mostly, biscuits, chocolate and malted milk tablets.

On account of the camp being so far in Germany it was not practical to try to come back thru the country to Poland or Switzerland because first you would have about three rivers and the Kiel Canal to cross, which would be very difficult because you would probably never succeed in finding a boat, and all bridges were guarded. Then the further thru Germany you went, the more difficult it would be for food, and the increased number of soldiers and the usual military precautions. You therefore, had the alternative of making your way upon the Baltic Coast and attempt to find a boat or build one and try reaching Sweden or Denmark, or going into Russia, and try making your way to Petrograd and Archangel, a long and very difficult trip.

A few of the men planned to go thru Russia, a few to the Baltic Coast and a number of others hoped to reach Warsaw, the capitol [sic] of Poland, and there try to get in touch with British agents, if possible. Civilian clothing, money, maps, compasses, etc., were smuggled into the camp in several different ways. Several times during the process of digging the tunnel, German officers and men would go thru the basement on inspection tours, while men were digging, and, partly thru luck, and the crowded condition of the basement they were never caught.

As the tunnel was nearing completion, they would send shifts of three and four men down so as to rush the work. During one of these eventful parties, the men were either a little careless, or else they had a sentry above with very sharp ears. However, the sentry heard a scraping noise going on underneath and reported the same to the commandant. The commandant at once sending an officer and men with a lantern down to investigate. This officer however, was either not suspicious or else neglected to examine the basement as thoroughly as he should. He re-appeared soon after, none the wiser. All this time three men were in the tunnel, and a fourth hiding elsewhere, during the inspection. At one time the Germans were within two feet of the elusive tunnel.

During the process of constructing the tunnel several amusing incidents occurred. For instance, at times you would see walking into the building or thru corridors somebody with a rain coat or heavy over-cotton; the day probably being one of the finest sunny days, where in reality you would prefer being undressed before an electric fan to cool off, instead of bundled up.

Then suddenly a German officer may pass you, or stop to talk, a bit too thick to imagine or question why you are bundled up so, on such a beautiful day. After finishing the conversation they salute, probably shake hands and part. The Germans going on to the office thinking perhaps what a fool that Englishman is all bundled up, and the Englishman probably complimenting himself on the Germans thickness and passed thru the corridor down some steps, wraps a few times, waits a few seconds, then takes from under his overcoat three or four boards, about two feet long and eight inches wide, hands them to his comrade and returns for more. Such is the risk he takes, knowing it is necessary if they wish to make the escape a success.

As the tunnel was nearing completion, the committee were perfecting the signals to be used. To make the escape a success, it was necessary to have a great number of men on the signaling squad, because it was important to change the men often, so that suspicions of the Germans were not aroused. As the escape was being made from the building, several men were required to be stationed on the third floor, so as to watch the sentries on the outside. It made no difference about those on the inside, the only thing necessary in their case was absolute silence, in talking and moving about underneath. The sentries box was directly overhead the tunnel.

Then to keep up the communication with those in the basement, runners were used from one floor to the next. Finally the eventful night arrived for the escape, and everybody was in high hopes of its success, because first, it was the first attempt made, and also the Germans from the commandant down, thought it was impossible for anyone to escape from such a well-guarded camp. In the party to make the attempt were sixteen, going in parties from one to three and four. It required a great deal of patience and caution in getting the sixteen men, together with their packs and civilian clothing into the basement, but by several clever tricks in engaging the attention of the Germans elsewhere, or by of a number of men innocently standing in front of the sentry the task was successfully accomplished.

The tunneling engineer had gone down ahead of the rest with one assistant to open up the tunnel and try if possible closing it up afterwards for future use. All the previous night men were on duty watching the outside sentries to see where they usually congregated the longest, and from those observations it was found to be somewhat unsatisfactory. So the night of the escape it was decided to have a little music and singing in building number three. To further aid the cause there were pre-arranged arguments on the top floor of building number one. Said arguments being very noisy. The

first men to escape thru the tunnel were an Australian a Scotchman and an American who were going together and try reaching the Baltic Coast, then by boat, if they found one to Sweden. As they were all aviators they were sure of success. HA, HA. Unfortunately the freedom of these three BOLD men was short and their dream of Murray's [a nightclub in London] *etc., was temporarily postponed.*

As they made their way along the wall they passed one sentry who for some reason, known only to himself and GOTT [a German word for God], *or unsuspicious, never challenged the three (Fleighers) German aviators, and on they marched towards the road. Their journey reached its climax. Another sentry on the road challenged them and marched them back to camp. The officer on duty at the time was new, and did not recognize the three men as officers due to their makeup and youth, but instead supposed them to be escaping privates from some other camp near-by never imagining anyone had escaped from his camp.*

Due to this unsuspiciousness on his part, the other men were all successful in making their escape. Along about midnight the men were identified as belonging to that camp, and then after a careful search the tunnel was discovered and for the first time the Germans realized the camp was not so difficult to escape from as they imagined. The German commander then sent his officer thru the buildings to check up, and see who and how many had escaped. Here more amusing incidents followed, as the stage was all set.

It was planned that should the escape be an entire success and in order to give the men all the time possible before they were missed, to put dummies in their beds, so that when the Germans would make their rounds, which they did every night, and at all hours, the beds would appear to be occupied. Well, you can imagine without much explanation the feelings of the Germans after pulling back the covers and finding instead of a Human being a log of wood, piece of stove-pipe or many other things, to deceive them. The result of the whole thing was that at nine o'clock roll call the following morning, it was found that of the 16 who escaped only three were captured, which considering the difficulties of the whole undertaking, was nothing short of remarkable.

In all the German prison camps they had at regular intervals, organized searches of both men and rooms, carried out by the camp officials. They also had in Germany an organized mob of THEORETICAL DETECTIVES— who traveled continuously from one camp to another. They were the so called Elite of the profession, with a wide reputation which struck terror

and fear to everybody except the prisoners themselves. The purpose of these searches was to find anything which would help men to escape, such as tools, compasses, money, civilian clothing, maps, fire-arms, poison, etc.

In our camp at Graudenz, the instruction the Germans posted on the bulletin board said that a certain noise on a Deutsche bugle indicated they desired to search our rooms and for us to assemble on the parade grounds. From the time the Bugle gave the first warning the men would probably take from five to ten minutes to assemble on the outside—depending on how long it would take us to hide our contraband.

When all were on the outside, in would march several companies of men with officers—every door, gate and window was guarded, with the corridors full of German soldiers while the search was going on. One half hour later, the search completed (nothing found) we would return to our rooms some would try to solve the problem, "Why is a German Search?" while others continued their plans for escape. As a result of this first escape, restrictions were placed upon the camp, which made future escapes impossible, so thought the Germans.

Then it became known to the Germans, who had escaped, they telegraphed their descriptions to the surrounding territory, and it was not long until the men were recaptured and returned to Graudenz. An Australian and Canadian succeeded in staying out for 2 weeks, before they were captured near Danzig. One of the men who started out by himself, made his way to the river, and there took possession of a row-boat, crossed the river, left the boat go on its course, and continued on by foot. The next day in the Grandeng [sic] Paper appeared a request, that if 16 Englishmen were seen sailing down the Vistula River, to notify authorities at Grandeng.

While those men were serving their time in the cells other plans for escape were being made. Some of these men in the cells passed the time by making copies of maps to be used on the next journey. Different plans were discussed, some tried with amusing results.

One Royal Flying Corps chap thought it was possible to get out in the laundry wagon. He waited some time for a suitable opportunity. It came one bright afternoon; so with the aid of half a dozen accomplices he was put inside a large bed sack, full of laundry. While six others carried him down the stairs, the German wagon driver stood gazing at them, yet never suspecting that there were about five too many. He was then thrown on top of other laundry with the intention of putting one or more bag over him, but not over his head, so he could breathe, so according to the instructions he was all covered up with the exception of his head, which space left about

one foot clear. Unfortunately this space was too close to the front of the wagon, and the space which was intended to give air to the chap inside the bag, made an ideal seat for the wagon driver, who climbed up and set right on the head of the aviator. As he was being smothered he began to shout by this time the wagon was outside the gate, when the guards hear him shouting then they began an investigation, which resulted in fourteen days in the cells.

The camp was now receiving Red Cross food parcels regularly, and thru the influence of a committee, chosen from the prisoners, they succeeded in convincing the commandant of the camp that the cooking facilities were inadequate for over seven hundred prisoners; he therefore ordered a large hot plate to be erected in the basement of building number Three. In the room adjoining the Germans had been throwing all the paper boxes from our food parcels. So that when the basement was opened up for us to do our cooking, the adjoining room was full of paper to within three feet of the ceiling. It did not take long until one Australian officer had an orderly soaping the windows so that the sentry whose beat was along here could not look in.

Guards were immediately stationed all around with suitable signals which gave quick action. In the far corner of the room, the paper was thrown up as far as the top to make room for a few men to work. Half the paper room was tunneled out first so to have a place to hide the dirt; then work commenced on the wall. With nothing but a pocket-knife we scraped the mortar from between the bricks and in that way we had in about four days a hole thru the wall about two feet square. If nothing unforeseen happened, it would be only a matter of about five days to complete this tunnel.

Just past the wall was a large water pipe which after being dug around formed a weak spot, but after it was filled up with rocks it was not thought it would give way. The amusing part of this tunnel was due to the fact that after the first tunnel was completed, it was necessary to use so many bed boards that it was feared that there would not be enough boards to line this tunnel with, but here the Germans came to our aid.

In practically every room in the camp the occupants had made some sort of a stove out of bricks and tin cans, and for fuel they used all sorts of things, including bed boards. From an investigation by the Germans they thought all the missing bed boards were used as fuel, and merely charge up the number of missing boards to the camp, then supplied others in place, which in turn were used as the lining for the second tunnel.

While one of the shifts were in the tunnel working, the sentry above for some reason walked too close to the wall and unfortunately for us stepped

on a weak spot, caving it in about six inches. He was a bit suspicious of a tunnel evidently, and kept kicking and jumping all around trying to find other weak spots. Underneath him the men were digging and working hard, and three more hours work would have completed the tunnel. As our work with the exception was camouflaged so perfectly, a hurried inspection by a German Sergeant-Major revealed nothing unusual in the paper room. It was therefore decided that due to the new difficulties just six of us would escape; so after roll call we were getting our packs etc., to-gether with the intention of going down in the basement before six in the evening, as the place was locked up at that time, and try to finish the tunnel and escape before further inspection.

However, while we were preparing we were informed that one of the German officers was making another inspection, so while we were down by the stove to see and hope that the tunnel would not be revealed to him, the German fell thru our artificial top, and accidentally discovered the tunnel. We were therefore thwarted in that attempt.

In connection also, with this tunnel, the General in charge of the prisoners camps in that region, and ordered that his paper be removed so as to prevent just such a plan as this one being successfully carried thru. The commandant however, did not consider it very dangerous and was not obeying. A few days before the near completion of the tunnel, the camp was informed of another visit of inspection by the general. There was then a rush to get the paper away. Wagons were brought up and were being filled up with the paper by the British Tommies who performed all the laboring work in the camp. This work was all overseen by a German Sergeant-Major. So by an Englishman starting a conversation with the Sergeant Major, giving him chocolates, cigarettes and flattering him as to his good looks and soldiering ability, the Tommies were instructed to pack the baskets full, with a very small quantity of paper, and to carry it out as though it was weighted a ton, and to take plenty of rest between trips.

The result of the General's visit was that he commended the commandant on getting rid of the paper before any more tunnels were attempted. And the commandant accepted the general's compliments while very cleverly keeping the general away from the basement where a tunnel was within a foot of completion. By this time a great many in the camp were getting the fever to escape. One officer thought that if he could get under the paper in the wagon, he would stand a good chance to make the undertaking a success. He succeeded in secreting himself in the wagon, which was driven thru the gates where everything is examined. The result

was that the officer in the wagon received the end of the German's bayonet in his jaw, and a few minutes later he had begun his fourteen days in a cell for an attempt to escape.

It was soon decided to build a tunnel from the Building 1. The plan was to tear up the flooring from under a bed and in that way enter the basement. Work was under way at once, and we soon had the wood flooring removed but under that we discovered very thick brick tiling, which would necessitate the use of chisle and hammer, and about three or four days work to go thru.

The question now arose that that noise would immediately raise the suspicions of the sentry with the result of an early investigation. Upon meditating it was thought that by sheer boldness or disregard the noise, the sentry would not be so suspecting, he probably would think men then were trying to escape would be as quiet as possible. We also had been in the habit of chopping wood in our rooms for fires—so with these two causes the task was continued. Some noise—the pounding was heard all over the building, the sentry would often stand over against the wall trying to solve the problem. The work, however, continued, for if stopping while the German was standing there he would probably be suspicious at once. As a matter of fact the whole thing seemed a huge joke to us, the majority being quite certain that this one above all could not be a success.

It was now getting on late October and cold weather was coming, which alone was a very serious drawback once we were out. To complete this tunnel would have taken a good two weeks, for having succeeded in getting thru the floor, it would then be necessary to remove and distribute secretly amongst all the rooms about two cords of wood [256 cubic feet], because the room we were to work from was piled ceiling high with wood. If successful in that we would then have a thick cement basement floor to go thru, then the building wall, and last the outside brick fence, escaping therefore has many hardships and hard manual labor. On the next escape an English infantry captain a South African flier and I agreed to go to-gether.

They had just finished serving time in cells for the previous escape, and were again anxious for another go. Our plan if we succeeded in escaping was to head in the direction of Warsaw, Poland, circle around it, but not entering, because it being full of German soldiers and then attempt to work our way on to Petrograd and Archangel a distance of about two thousand miles. We were hoping and expecting of course that once into Poland and Russia the inhabitants would be friendly toward us, and give what assistance to us that was in their power. As we were anxious to make

our escape without delay, we decided to make an attempt over the fences, on the first favorable night.

It was possible for us to put the entire lights in the camp out of commission, but in doing that the Germans would know at once that an escape was under way. So our plan was to place men at certain points of vantage and with suitable signals to tell us that positions of the guards on the outside of the fence and the inside, then to get over at the first favorable minute.

It was possible to watch all guards except one, along the out fence of number two building. In his case, we would have to trust to luck. Because in the time it would take a man to come from number two building, the other would then probably be in the wrong place. As we had five German sentries to handle, it was difficult to have them all simultaneously in a position to our liking. Our plan was to cut away the barbed-wire on the top of a sentry-box and by standing on that stretch a long plank from the first fence to the second. On the appointed night with the aid of several others, we secreted ourselves in the building. Then by opening a window, it was possible to step out on top the sentry-box and cut away the barbed wire. It was long thereafter until we had stretched the board across, and we three were on the outside of the fences.

Here, however, luck had played against us in regards to the sentry on the other wall. Unfortunately for us, just at the time we had jumped he appeared at the corner about thirty yards from us. Right across the road from us, some forty feet, was a large pile of bricks and further down was a stone quarry. We made for the other side of the road, and in doing so the sentry challenged us "HALT." We kept going and he fired at us, the streak of fire was too close for comfort, but before he could fire a second time we had dodged behind the bricks and a little hill.

I here got separated from my companions, and continued down until I got into the stone quarry. It was very dark and by making haste it was possible for me to get away I figured. I climbed up the side of the quarry and made my way into a potato field and lied down to rest for a few minutes. By crawling along and keeping a careful lookout, and lying low whenever Germans would pass, I succeeded in reaching the bank of a railroad where I rested for fifteen minutes. I was still within two blocks of our camp.

After resting up I started down the track at a fast pace, intending to get as far away the first night from the camp as possible. I had given up all hope of finding my companions, and was quite surprised when passing a woods to hear some one whistle and out stepped the two lost ones. We walked down

the railroad for a few miles, then proceeded on a wagon road, several times dodging off to the side in order to prevent passing pedestrians from seeing us.

A few miles from us was the aviator's school. They were evidently informed of our departure, for the sky was being lighted up as day for miles around. This was continued for at least two hours—and by being very careful we succeeded in eluding anybody who may have been in the vicinity. According to our plans we walked along another railroad until dawn the next morning. It was only possible to travel by night and keep under cover in day-time.

Unfortunately for us there was a very thick dew and a light rain falling, but necessity knows no law, for it was near daylight and was therefore essential that we get in hiding at once. Ahead of us was a small woods which we entered, finding as suitable a place as possible we stretched out on the ground with our shoes off, attempting to sleep. On account of the cold and rain it was impossible for us to sleep, then again if we stayed in such an exposed position to the climatic conditions we would be in no condition to continue our journey when darkness came. So, accordingly with a search in the vicinity we found an immense hay bar, which we slept in the rest of the day.

The following night was similar to the preceding one—resting every few hours on the approach of daylight we succeeded in finding another hay barn to spend the day. It was impossible for us to sleep however because the farm hands were in the barn the entire day talking and singing.

From loss of sleep and proper food we were quite tired when we continued our journey for the third night. We were now nearing a town of considerable size, and were debating on rather we should go thru the town or around it. We then remembered that the Australians had succeeded in passing thru it without trouble, so we decided to do the same. The result of this decision was that we spent the rest of the night in the town jail. The following morning we were a very unhappy trio. We were marched three miles to a railway station, where we were escorted to another camp about thirty miles away. To complete the journey we changed trains three times.

PART II
THE RESTLESS RAPTOR

CHAPTER 6

HESITANT HERO

*When Paul Baer quietly slipped out of town about three years ago nobody
here knew of the fact and even if it had been known, nobody would have been
particularly concerned or interested. But now when he comes back everybody
knows it and everybody is concerned and interested. There's a reason.*[97]

F ort Wayne's one and only ace came home to a proud city eager to
honor him and his accomplishments. The Rotary Club and the
chamber of commerce had planned events to mark his return home,
and the local press made sure that the citizenry was aware. "Rotary Club
Arranges for Public Affair for Ace on Thursday Afternoon: EVERYBODY IS
INVITED," read the headline on page fourteen in the February 25 issue of the
Fort Wayne Journal-Gazette. A close look at the story offered a hint that Baer
was not looking forward to the attention:

> *Fort Wayne will have its first opportunity on Thursday afternoon of this
> week to do honor to one of its real heroes, Aviator Paul F. Baer. The event
> will take the form of a public reception in the Chamber of Commerce,
> between the hours of 2 and 4 in the afternoon, in charge of the Fort Wayne
> Rotary Club. The ladies are especially invited. Paul Baer will be the guest
> of the Rotarians at a luncheon to be served at an extra meeting of the club
> Thursday noon, this to be followed by the public event. At the club meeting,
> the noted aviator…will probably make a brief address, but it is rather to
> see the daring flier than to induce him to review his harrowing experiences*

in the air and in the hun prisons during weary months of suffering that the
members of the club will assemble Thursday.[98]

The article described an interview with Baer's mother, who had visited him in Washington several days earlier. She was straightforward about her son's reticence to shine a spotlight on his wartime experiences:

When I saw Paul in Washington…he looked very well indeed, but he was still quite nervous. We find it difficult to induce him to speak of his war experiences. When he went to Washington, he chose to shield himself from observation by wearing civilian clothes, as he does not seek any notoriety or praise for doing his duty. His brother asked him if he did not feel proud of the honor which has been bestowed upon him by everyone who knows of the splendid work he did. "Honor!" said he, "No, for when I stop to think of all that occurred during those days, days of horror, there comes a feeling of anything but honor in it at all." I don't know whether Paul will feel like speaking in public or not. Possibly he will ask to be excused from referring to his harrowing experiences, and possibly he may feel like telling a part of the story which he has told me and which causes us to be very proud of him.[99]

Like it or not, Baer drew attention, which included having his picture appear on several local movie theater screens with other aces. No one, especially the local press, disputed Lieutenant Paul Baer's status as a genuine hero. However, Baer's steadfast self-effacing modesty and intractable resistance to talk about himself created a festering frustration among reporters and editors. One newspaper even took the opportunity to take a polite poke at him:

Paul Baer in his brief greeting to the Rotary Club yesterday remarked that a local paper had taken something less than seventy-five words he had passed to its reporter and produced a two column "interview." This can readily be accepted, for a reporter for this paper disgustedly declared that of all the hard-boiled eggs he had ever tried to crack Baer was the hardest. While appreciating his modesty, it may be remarked that reticence can be carried to as great an extreme as unbridled loquacity. The young man has a story to tell that might be given without either the appearance of boasting or of idle garrulity. Unusual experiences have been his and he might with all propriety tell his story.[100]

In spite of all this, Baer gave a short talk "expressing his appreciation for the honor that was being accorded him by Fort Wayne."[101] At a public reception in the lobby of the Fort Wayne Chamber of Commerce, "hundreds of persons passed in line to greet him."[102] Baer found the entire affair exhausting:

> *Fort Wayne yesterday afternoon extended the glad hand to Lieutenant Paul F. Baer, Indiana's premier ace, in the form of a public reception given at the chamber of commerce under the auspices of the Fort Wayne Rotary club. Lieutenant Baer declared, after the informal function was finished, that he had enjoyed the occasion, but those nearest to his heart are of the opinion that the occasion was more difficult for him than fighting German air raiders, as the young aviator shrinks from all manner of display and has requested as little public attention as possible during his stay in the city with his mother, Mrs. Emma Dyer.[103]*

At noon, Baer joined a group that included his mother; his sister, Mabel; a friend, Lieutenant Harry Runser; and Mrs. J.F. Smith, mother of legendary Fort Wayne aviation pioneer Art Smith, as the guests of the Rotary Club's luncheon at the chamber of commerce. Remarks introducing the mothers of Indiana's two most famous flyers, Emma and Mrs. Smith, were greeted with cheers as the diners rose to their feet. A rousing welcome for Baer followed, after which Baer was asked if he would tell the Rotarians something of his experiences abroad. The newspaper captured this rare instance of Baer speaking in public, reporting it as follows:

> *Although his words were few, the members of the family declare that he said more about his experience in the brief address than at any time, even to those who are most closely related to him; for Paul Baer is not the type of man to parade his deeds. "I happened to be on a little trip to Italy during the fore part of 1916," said he in telling of his experiences before America entered the war, "and there I saw many of the refugees and the wounded, and as we went to various places in Italy and I saw the condition of things. I wanted to go to France and get into it myself, for I was certain that my own country would be in it before long. I went to France as soon as I could and entered the service and was soon transferred to the flying division....In the war, it was natural for each country to think its own army was superior to the others. Great Britain thought this of her army, France did likewise, and so America has held this opinion of its own army. But thousands of*

Americans are now coming back with a new view of things—an education along many lines which they could not get in any college. Their views are changed with reference to Great Britain, for we appreciate all that our allies have done in the war, which is much more than the American army did. We who have been over there have learned to regard in its true light all that Great Britain and our other allies have done for the world, and this makes the war worth while.…My personal experiences have not been out of the ordinary. I am grateful to the people of Fort Wayne for the kindness shown to me and my mother." This was Paul Baer's "speech." Is there anything of the braggadocio in it? Would anyone suspect from it that his name is a household word abroad and that he played a part in the winning of the war second to few of the men who were sent from the shores of America to fight the battle of world freedom?[104]

Someone in the audience asked Baer to speak about his experiences while being held a prisoner. He summed up the months of captivity in a few moments:

I woke up in a German dressing station, painted with iodine from head to foot, and swathed in paper bandages. After spending several days in this station, I was sent to a town in Belgium. The food was bad, but the attention afforded me was as good as they could give. After being in hospitals in eastern Prussia and Poland, I was taken to Rumania, and later to a British officers' camp where there were six hundred British officers. I was the only American officer. There were three American darkies there. Here we began to appreciate what the British really are and to learn that they think a great deal better of America than we have been led to believe. Here the food was not good. We were fortunate to get hot water and carrots or turnips. We had black bread early in the day and imagined it the rest of the time. After the British Red Cross was able to get food to us we fared better. Our packages were always rifled of their contents. In saying that the officers were always well treated, I am speaking only of the officers and not of the men, for I know nothing of their treatment. We knew of the armistice the day it was signed, as we were allowed to see the German newspapers every day. These papers did not give us real facts, but we had a way of reading between the lines which gave us a pretty good knowledge of what was really going on.[105]

Baer's "bosom friend" Lieutenant Runser spoke briefly, at Baer's request. Runser, who was a longtime resident of Fort Wayne, was ready to sail for France to follow in Baer's footsteps when the Armistice was signed in November 1918. Runser "made a delightful talk which was vigorously applauded."[106]

At the conclusion of the luncheon, a reception was held for Baer. He was now itching to be anywhere but there. He devised a way to make his escape:

> *Many women and children came and grasped the hand of the young man whom Fort Wayne is proud to honor, and an hour—a happy hour for the visitors but an agonizing hour for Paul Baer—was thus spent. Indeed, the flyer took refuge in a request to be excused from prolonging the affair later than 3 o'clock, although the event had been announced to continue until 4. In all this, Fort Wayne recognizes in Lieutenant Baer the qualities which make the true soldier, who shrinks from display but is willing to exhibit the greatest courage in the saving of his country. [An] orchestra provided music for the event, and the upper lobby was decorated with the flags of the allies and palms.*[107]

Baer may have shortened his discomfort by cutting out early from the hometown celebration in his honor, but he wasn't finished with adulation from the press. This included a lengthy and doting piece by a prominent New York newspaper woman at the *New York Telegram.*

CHAPTER 7

ANOTHER WAR

T he idea of an American flying club based in New York City and
designed to attract pilots and others willing to promote aviation
was born in Europe in the late stages of the war. An immediate
obstacle presented itself: where to obtain funding. A similar organization,
the Royal Flying Club in London, for example, was financed by a group of
wealthy benefactors, including the king of England.

But the rank-and-file membership, which would be composed of the
young boys who flew in the war, would have no money and could not be
expected to assume the financial burden of operating the club. For them,
the club's primary object was to provide a home in the city and a base
to promote aviation to the nation. Organizers had to make the dues so
moderate that "the flying men" could join. And so they did. Paul Baer was
one of the first to join.

Founded in March 1919, the American Flying Club got off to a strong
start. By April, membership numbered over seven hundred and was
growing. Members included many luminaries such as Chauncey "Chance"
Vought (aviation pioneer and engineer) and Baer the ace, both directors of
the organization. A visitor described what he encountered only weeks after
the club opened:

It seems scarcely possible that the American Flying Club with less than
two months to its age could hide an effect of newness. However, it did to
the visitor yesterday who went up to 9 and 11 East Thirty-Eighth street

to see what it was and why it was. This visitor stepped into a tiny entresol
[mezzanine] fitted with a clerk's desk and a telephone. Circular stairs on
either side lead to the main floor of the clubroom and a big, long propeller
of polished mahogany suspended over the marble balcony gave atmosphere
at once. On the floor above the lounge is a splendid room fronting the street
which has been fitted up as a library. It is the aim of the club to make
this the most complete aeronautical library in the world. There does not
now exist a complete library of this subject either in this country or in
Europe. Many of the early works on the subject are out of print, many
valuable articles worthy of long life are to be found only in the pages of
magazines.[108]

The club provided Baer a comfortable base from which to consider his
next options, as well as a safe place for enjoying time with pilot friends, like
Eddie Rickenbacker, whose 94th Aero Squadron held a reunion dinner in
June with a guest appearance by Elsie Janis, a singer, songwriter and actress
who performed for troops in Europe. The highlight of the evening was Janis
cutting a cake that was decorated with the hat-in-the-ring insignia of the
squadron. According to a newspaper report, the members bestowed an
honorary military title on Janis:

Elsie Janis, whose entertainment of the soldiers overseas is well known,
was the guest of honor. She had a great time and cut a special cake for the
forty or fifty guests with a sword belonging to the club. According to the
list of guests given out by the club, Elsie was the ranking officer present.
They called her "General." Mrs. Janis, Elsie's mother, was among those
present.[109]

Despite the comfortable camaraderie and security of the club, Baer could
not ease into peacetime living. He did obtain a civilian commercial pilot's
license from the Joint Army and Navy Board of Aeronautics in May 1919.[110]
But a war between the Polish republic and Russia's new Bolshevik regime
of Vladimir Ilyich Lenin caught his attention. For the long-suffering Polish
people, the roots of the war ran deep:

The campaign featured fierce cavalry charges with modern blitzkrieg
military tactics. For a century and a quarter, the once-formidable Polish
nation was a political nonentity, having been dismembered by Prussia,
Austria and Russia. Severe Germanization and Russification efforts, aimed

at the destruction of the Polish language and culture, were imposed upon the population during the 19th century. Although such campaigns had little effect, by the turn of the century only the most optimistic Polish patriots could still dream of independence.[111]

Baer threw his hat in the ring and headed back to Europe. His goal was to organize a volunteer squadron of fighter pilots:

Lieut. Paul F. Baer, Fort Wayne's greatest hero of military aviation and an American Ace of international repute, has gone back overseas to fight with the Polish army against the Bolsheviks. This information reached this city today in a letter from the aviator's mother, Mrs. Emma Baer Dyer, 1304 Maud Street, who has been with her son at his station in Washington, D.C., for the past three weeks. "He has accepted a responsible position with the Polish government," wrote Lieutenant Baer's mother. "No doubt the people of Fort Wayne will be surprised to hear this, but he was determined to go."[112]

Baer's sudden departure for Europe disrupted another attempt for his hometown to honor him as news of his medals spread:

Two months ago [August] *authorities communicated to the late Lieutenant Colonel Thomas F. Ryan, then Major Ryan, in charge of recruiting in Indiana, that the French Croix de Guerre would be awarded Lieutenant Baer and at that time it was Major Ryan's plan to have the formal presentation in this city. These plans were given up after the sudden death of Lieutenant Colonel Ryan last week and the medal was presented to Lieutenant Baer at the eastern camp.*[113]

Details about Baer's assignment began to emerge in October and revealed that the Fort Wayne hero had been in direct discussions with the Polish premier and senior military planners in the Polish army:

A squadron of twenty American pilots and observers, and the usual enlisted personnel of the unit, is to be raised for the Polish army, according to word received by the American Flying Club from Lieut. Paul F. Baer, an American ace now serving as an officer in the army of Premier [Ignacy] *Paderewski* [Polish pianist, composer and statesman]. *At the present time, the Polish army of 750,000 men contains a squadron of*

American volunteer fliers, who are equipped with Sopwith Camels and Fokker fighting machines. Lieutenant Baer, who reached Paris on October 3, received permission, after a conference with Paderewski and General Roywadowski [General Tadeusz Jordan-Rozwadowski], *chief of the Polish mission in Paris, to recruit another squadron and to secure the necessary equipment in the United States.*[114]

Meanwhile, in October 1919, authorities at the Indiana armed forces recruiting office received word that Baer had been awarded the French *Croix de Guerre* with palms. Baer apparently also cashed in on a personal endorsement, according to a local newspaper story:

Friends of Lieut. Baer will be interested in a full page advertisement in a weekly publication in which the young Fort Wayne flier with three other French and British aces is pictured in connection with his comment on accessories used on aeroplane engines. His letter, which is reproduced, is written from the American Flying Club, 11 East 38th street, New York City. In the advertisement Lieut. Baer is accredited with the Distinguished Service Cross (American) with oak leaf, the Croix de Guerre (French) with palms and a citation for the French Legion of Honor, a still more distinguished recognition of gallantry. Lieut. Baer has been located at an eastern camp for some time and it was finally decided to forward the medal to him. With the death of Col. Ryan, plans for a public ceremony will be abandoned for the time being at least, according to Postmaster Ed Miller, who has been cooperating with Col. Ryan in planning the presentation here.[115]

In order to organize a squadron to fight with the Polish air force, Baer returned to America and began a recruiting operation. He was looking for fearless pilots who liked the adventure associated with a good cause:

Major Paul Baer...has returned to the United States to interest aviators here in enlisting in the service of Poland. "Poland has 800,000 in uniform, who have sworn to regain their lost provinces and to maintain their new national independence against all foes," said Major Baer. "On their battlefront they are fighting not only Bolshevists, but Germans in Russian uniforms. You must know that Germany has refused to give up certain territory she now holds until the United States ratifies the Peace Treaty. I have been authorized to take to Poland in about a month the

premier organization of their air service. We must have at least fifteen first-class pilots and twenty-five or thirty expert mechanics. Airplanes, too, will be needed, though just where these will be secured has not been decided." Major Baer is making his headquarters at the American Flying Club.[116]

To raise awareness, Baer placed the following classified advertisement in New York newspapers:[117]

WANTED—For service somewhere in Poland and along the Russian frontier, fifteen American flyers who will leave at once to help fight the world's battle against the bolsheviki. Address Lieut. Paul Baer, American Flying club, No. 11 East Thirty-Eight street, New York city.

As the first anniversary of the Armistice approached, the American Flying Club turned into "a huge wartime aviation field." Plans for a reunion dinner for American aces drew pilots from all corners of the country to New York's Hotel Commodore. Organizers hoped to "bring back vividly the good old days when it was 'out with the dawn' and 'back if you're lucky'":

In one of the Armistice Day gabfests at the Flying Club was Paul Baer, the first American Ace. Baer is now Major Paul Baer of the Polish Air Force, and it is his claim that he came all the way from Poland to attend tonight's dinner. He had planned to return to America at a later date to obtain recruits for the Polish Air Force, but when he learned of the Armistice Day celebration he speeded up his plans so that he could arrive in time for the dinner.[118]

Meanwhile, despite the social activities of the flying club and the many duties involved in the planning, recruiting and preparing for his adventure in Poland, Baer's thoughts returned to his hometown at Christmastime. From a distance safe from any publicity, he sent holiday greetings to the citizens of Fort Wayne:

Lieutenant Paul F. Baer, Fort Wayne's hero airman and American Ace of Aces, has asked the News and Sentinel to extend Fort Wayne his heartiest wishes for a Merry Christmas. Though being unable to spend Christmas in this city…the aviator's thoughts at approaching Yuletide returned to the city of his birth, and he asked the privilege of wishing each and every one of his fellow citizens a Merry Christmas. This will be Lieutenant Baer's

fourth consecutive Christmas away from home by reason of his being in the service of his country. He spent Christmas of 1916 with the American punitive expedition in Mexico. In 1917, he was making his splendid record of bringing down German flyers over the German lines. In 1918, he spent Christmas in an American Army camp in France, having just been released from a German prison camp, where he had been detained following his capture by a boche flyer.[119]

CHAPTER 8

D'ARTAGNAN OF THE AIR

Poland's struggle caught Baer's eye, and Baer's new adventure caught the eye of New York newspaperwoman Jane Dixon.

Dixon was a complex person ahead of her time, a pioneer sportswriter in the 1920s for the *New York Telegram*, where she covered the brutal, male-dominated world of boxing. She crafted richly descriptive stories that focused not on the blow-by-blow technical aspects of the bouts but rather on the personalities of the boxers and the intricacies of their lives. A prolific writer, Dixon also contributed to the women's section of the *Telegram*, promoting rights for women while holding to her conviction that raising a family is a woman's top priority. Colleagues admired her for her steady demeanor under pressure and her range of writing styles—she could easily switch from cranking out spot news stories about city mayhem and tragedy on tight deadlines to crafting sweet-tasting features providing tinctures to lift the spirit of downtrodden and underprivileged readers.

It follows that when Dixon learned about Baer's uphill efforts to recruit volunteers to help Poland's army, coupled with the stories of his heroic exploits in the war, here was a tale to be told about a unique personality, one that deserved her special treatment. Perhaps inspired by the use of nicknames for boxers, Dixon dubbed Baer "D'Artagnan"—the name of one of the principal characters in Alexandre Dumas's nineteenth-century work *The Three Musketeers*. One can only imagine how Baer reacted to the flowery description she painted of him and his new mission:[120]

Plain Paul Baer, born and bred in America, and brought to fruition on those battlefields of Europe where the blood of brave surged and spilled in a crimson tide that should wipe out for all time the trail of the spiked helmet…traveling the trackless waste of the skies, plane singing the siren song of who knows what strange adventure, heart singing the matchless melody of youth and the conquests thereof. Paul Baer, of Fort Wayne, Indiana, USA, watchful, waiting, poised to strike where the shaggy head of anarchism bares its hunger pointed fangs and the red tongue of bolshevism licks its parched lips in anticipation of crime and chaos to be. Here we have, in that matchless setting of modern warfare, beside which all trappings of the past fade into insignificance—the battle plane—a real present day soldier of fortune.

Dixon, sensitive that the phrase "soldier of fortune" might suggest that Baer was driven by ulterior mercenary motives rather than a genuine urge to help, clarified that it offered a high compliment to this young "challenger of chance":

A soldier of fortune, as we know him today, is of quite another cast. He is a man who dares and does to the limit of human possibilities counting his life but a pawn in the gigantic chaos game of liberty and the pursuit of happiness. Once upon a time I asked a man by name Sam Dreben, sometimes called "The Fighting Jew," and one of the most picturesque "bayonet busters" the Texas border ever knew, to give me the definition of a soldier of fortune. "A soldier of fortune," opined Sam, gazing through the amber of his Three Roses [whiskey] and rubbing his close-cropped head with fingers trained to the feel of a thousand triggers, "a soldier of fortune is a bird who fights where he is paid to fight, or where the fighting is good."

Dixon explained to readers that the man named Sam was a veteran of numerous revolutions in Mexico and a few dozen "jams" in South America and was a proud member of the second class of his soldier of fortune definition—the bird who fights wherever the fighting is good. The class, she wrote, that Baer elected to join. But why this particular struggle?

"What gave me the notion to go over and help out Poland?" he asked. Smiling his quiet smile and strumming his fingers to the tune of "The Long, Long Trail," a boy with the shadow of a mustache on his upper lip and the silver wings embroidered on his chest, was drumming softly on the

club piano. "Oh, I don't know. I guess because they need us so deucedly [damnably] *bad over there. Some one has to help out, you know, or we'll be overrun by that ragamuffin outfit, the bolsheviki. I think, as Americans, we pretty well owe it to Poland to do our bit. They are fighting the world's battle today, those brave people. And they're fighting on empty stomachs, too, without food, clothes or any of the things that help keep up a soldier's morale. They are brave fellows, those Poles. A Polish officer knows if he is wounded there is not one chance in a million for him unless he happens to fall near a line of transportation. Medical supplies are so scarce they are practically nil. A wounded man must die of gangrene for want of a dash of good old iodine. Transportation facilities from the Polish front to some place where the men can get medical attention are almost entirely lacking. There are only a few ambulances, a few hospitals, a pitiable shortage of Red Cross supplies and workers.*

Dixon asked Baer to name the "remedy" that would help Poland overcome its struggle. Baer answered that what the Polish army needs "is credit from America. They will pay it back richly. Poland is a country of vast undeveloped wealth. It embraces within its borders 200,000 square acres. All the Polish people need is freedom and an opportunity to develop their country without interference." Dixon wondered if Baer by himself and with the help of a handful of pilots could actually help Poland achieve that:

Lieut. Paul Baer broke into one of his quiet smiles. "I can do my bit," he parried. Then he confided to me something of his purpose. "I am going to take fifteen trained American flyers—pilots and observers—over as volunteers in the Polish army," he explained. "Our outfit will be known as the Pulaski squadron, after the famous Polish general who distinguished himself in Washington's army. Thus we will be paying back an old and honorable debt. I am authorized by [Premier Ignacy] *Paderewski* [a composer and proponent of Polish independence] *to organize this unit. We will leave in about a month, go straight to headquarters, where we will be commissioned officers in the Polish army and will be sent immediately to the front. It is the hope of Polish military authorities high in command that we will be able to bring their air service somewhere near the standard maintained by Germany. It might interest you to know that Germany is at least two years ahead of the world in her air service in everything pertaining to a plane from production to improvements and usage. Many of the bolshevist leaders are Boches who have left their own*

army and are wearing the Russian uniform. We must put down this deadly menace to the glory of the victory we have so recently won. Our men will be used as instructors, and, of course, will do some flying on the front.

When Dixon worried that the endeavor was "pretty dangerous business" and that "it would be terrible to fall into the hands of that hateful mob," Baer played the role of the fearless soldier of fortune, displaying his heart of adventure and the energy of his youth:

"That," chuckled Lieut. Paul Baer, "is the sporting chance. It wouldn't be a game without a hazard." "Your fifteen tried men and true understand the chance?" I persisted. "You bet they understand the chance. They know living is going to be mighty tough. That is why I am taking only fellows who have been up against the war game. They know all about what is in store for them if they are captured by the reds. It is common knowledge that the bolsheviki maintain a regular "torture battalion," which practices every kind of medieval cruelty upon prisoners. I believe it is made up largely of Chinese. Those quitters haven't the courage to do the dirty work themselves. It's a good gamble either you get away with it or you don't." And so they go, the fifteen tried and true, to help keep the torch in the hand of universal liberty, trimmed and burning.

Dixon used her considerable powers of observation to give readers a sketch of the "middle west *d'Artagnan*":

A sturdy lad, built close to the ground, right square as to feature, especially in the region of the jaw, blue of eyes as the arch of an Indiana sky on a balmy June morning, pink of cheek like an Indiana pippin, brown haired, strong handed, straight in limb and look. Quiet, too, he is retiring to the point of bashfulness. In the course of procuring the afore written facts of the expedition for freedom I asked some extra hundred questions. I learned that Lieutenant Baer was the first of the American aces, likewise the first American to receive the D.S.C. At the outbreak of war in Europe, Paul Baer, a salesman in the employ of the Cadillac Motor Car Company, Detroit, Michigan, donned his hat, slipped into his topcoat, and caught the first outgoing steamer for France. He was barely twenty-two. Soldiering, it seems, was born in the boy. He enlisted in the French aviation service, was transferred to the Lafayette Escadrille in January, 1918, and in May of the same year was shot down by a German plane in a battle over

80

the Somme sector. Baer fell 12,000 feet, landing in a treetop behind the German lines. He was badly smashed, was taken prisoner, and spent the rest of the war days fretting and fuming in enemy prison camps. "I owe my life to that tree," he says. And that is as much as he will elaborate on the great adventure. It is a far call from Fort Wayne, Ind., the town of young Baer's birth, to a battle front somewhere on the Polish-Russian frontier. But youth will be served. A soldier of fortune is born, not made. Home and distance and danger are lost in the call to conquest. American flyers, American money, French and British planes. What a pity it cannot be American planes! What a blot on the fair fame of American production, American ingenuity, American patriotism, that the brave must go elsewhere for the wings on which they fly to glory!

Baer told Dixon that his Pulaski squadron was intended to "be a free gift of the United States to Poland," as a thank-you to a country that provided excellent fighters to the American Expeditionary Force in the war. He expressed hope that "every liberty loving American" would get behind the effort. Baer was also realistic about the dangers his squadron faced:

"And if you are captured, if your plane comes down somewhere behind the lines of the bolsheviki?" I asked, wondering at the eager note in the young voice, the unquestionable fires of hope dancing in the deep blue eyes as they threw their searchlights out across far fields of adventure. "Well"—with the true middle west drawl—"I suppose if a fellow comes down on the wrong side of the game he is out of luck, that's all."

CHAPTER 9

LIFE AFTER WAR

L uck turned out to be on Baer's side in Poland, and he returned safely to explore new adventures. But he wasn't the only member of his family who continued to seek change.

Six years after her divorce from second husband Frederick Dyer, Emma married her third husband, Martin D. Shroyer, on June 10, 1920, in Detroit. Shroyer, fifty-seven, was a carpenter; Emma was now fifty-two years old.[121] Meanwhile, after Baer returned from Poland, he spent the rest of the 1920s seemingly jumping through an eclectic collection of jobs. Some of the positions are highlighted here, including stints working in the oil industry, the movies and for the government.

In 1922, Baer served as secretary and treasurer of the Bert Blair Oil Company and lived for a time in Mexia, Texas, about eighty-five miles southeast of Dallas. The area was a magnet for war veterans drawn to the oil business:

> *Soon after their return to the United States, Mexia began to claim the attention of the oil world as the center of petroleum activities in Texas and, as a result, hundreds, if not more than a thousand former soldiers and veterans of the memorable conflict came here and worked in the development of the oil field. Most of them are modest about mentioning their previous services and their presence here is usually learned by accident, if learned at all. Some of the men here had a part in making history during the war which any people would have an undisputed right to be proud. Occasionally,*

information regarding some such men is gained by chance. For example, a News reporter this week learned something about Paul Baer of this city which it is well for everyone here to know. The reporter had known Mr. Baer for many months, he thought, but after being informed by others of some of his past history, he decided that he didn't know him at all. For several months since he came here he has been with the E.L. Smith Oil Company, Inc., and has resigned only recently to become affiliated as an officer with the Bert Blair Oil Company. Paul Baer was shot down in his plane by the Germans in May 1918, and was held a prisoner in Germany until the Armistice, by which time his bones had mended sufficiently for him to walk. His bones were cleverly set by German doctors, and although badly shot and broken at that time, Baer is now apparently as sound as anyone. Mr. Baer has been associated with Bert Blair in the oil business since coming to Texas and is especially proficient in corporation work incident to manufacturing.[122]

Back home, the local citizens still yearned to honor Baer for his valor in the war. In June 1925, a ceremony was organized to christen Fort Wayne's airport north of the city with Baer's name. Thousands attended the event, but Baer was not among them:

The first municipal aviation field in this section of the country was formally dedicated with imposing ceremonies here today. Mayor William J. Hosey made the principal address, in which he tendered the field of 150 acres to the "cause of aviation and to the United States government for military operations as a part of the national defense scheme." The field was christened the Paul Frank Baer Field in honor of Paul Frank Baer, formerly of Fort Wayne, World War hero, who was officially credited with shooting down nine enemy planes and unofficially with ten more. His mother, Mrs. Emma Shroyer, was the guest of honor at the ceremony. Captain Charles Nungesser, of the French Army, who is credited with 130 enemy planes, was a guest and gave exhibition flights. Planes were here from McCook Field, Dayton, OH, and from neighboring cities. It was estimated that over 5,000 persons took part in the ceremonies at the aviation field, while thousands of others watched the maneuvers of the visiting planes from vantage points in other parts of the city.[123]

At the field, located just over four miles north of the city on Ludwig Road, the atmosphere was festive and drew a large crowd of aviation enthusiasts.

Songs performed by the *News-Sentinel*'s boys' band "were a pleasing feature." The first guest speaker, E.G. Hoffman, co-owner of the *Journal-Gazette* and a member of the Democratic National Committee in Indiana from 1920 to 1921, mentioned "the appropriateness of linking the dedication of the field with the national observance of Defense Day." Hoffman also "pointed out the value of the national defense act and said that this country must be prepared to protect its institutions." After Hoffman's remarks, more pomp and a speech by Fort Wayne's mayor followed:

> *The band played "The Star Spangled Banner," the two national guard units present, company K and service company, of the One Hundred and Fifty-second infantry, raised the flag. The dedication address was made by Mayor William J. Hosey. "By purchasing this field and dedicating it to the cause of aviation, the city of Fort Wayne is taking a forward step," he declared. "Our city has gained three distinct advantages by this act—the government may establish a flying school here, the city may be placed on one or more mail routes and we are further along in the commercial development of aviation." A sheepskin parchment was presented to Captain Nungesser in appreciation of his part in the ceremony, and he responded with a short address.* [124]

Baer, according to one report, was unable to witness the christening of his hometown's airport in his name because he was "in California." [125] So, after Nungesser finished performing acrobatic maneuvers to the crowd's delight, organizers—eager to honor *someone*—presented the French flier with the parchment bearing "a certificate of appreciation from the Reserve Officers Corps." [126] Apparently, Baer was working for Hollywood movie studios "when located and was told of this latest honor by telegram. He didn't show up until an air show he was with happened to pass by over a year later." [127] The telegram, from Fort Wayne mayor William J Hosey, read as follows:

> *It gives us great satisfaction to inform you officially that the new municipal landing field, consisting of 156 acres, recently purchased by the City of Fort Wayne was with appropriate ceremony dedicated to you and named Paul Frank Baer field this afternoon. We are happy to have this opportunity of knowing that one of our native sons whose record makes him one of the outstanding figures in aviation has been honored by Fort Wayne.* [128]

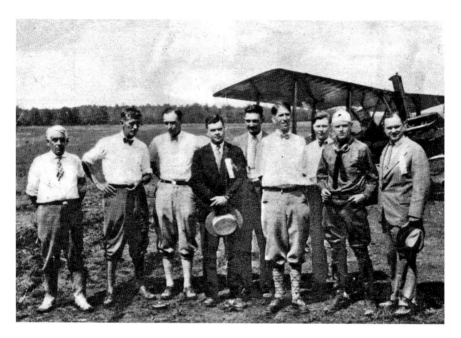

Baer missed the official ceremony naming his hometown airport in his honor, but he is shown here *(fourth from left)* making his first visit. *Paul Baer Collection, Allen County–Fort Wayne Historical Society.*

What exactly was Baer doing in Hollywood? The answers remained characteristically elusive. One article noted that he "was hundreds of miles from here grinding out movie thrillers in Hollywood." Another called him the "movie camera man of Hollywood."[129] The same article tried to put the best face on Baer's absence, explaining that "owing to lack of time in preparing the dedication program, boosters of the event were unable to obtain the presence of Baer."

Emma carried on bravely. "His mother occupied a seat in the speaker's stand and expressed a mother's pride for the honor bestowed upon her son," reported a Fort Wayne newspaper,[130] which also noted Baer "is a movie cameraman." The city's fondness for its ace still percolated. The paper reported that "more than 5,000 people watched" the dedication ceremonies.

In the summer of 1925, more wanderlust called to Baer, again attracting him to come to the aid of France in a military conflict, this time in northern Morocco. Abd el-Krim, a political and military leader, led a rebellion by a coalition of Rif tribes against the Spanish colonization of Rif, an area of northern Morocco. The French intervened in 1925,

and news that American aviators in Paris had volunteered their services as combat units against the Rif rebellion spread rapidly by radio, heliograph and telephone from one aerodrome to another. A number of French pilots involved in the conflict recalled the world war days when Yankee flyers became their comrades in arms to fight the sky battles. To encourage volunteers, the airmen fighting in the skies over the Ouergha River in Morocco employed the phrase "the water is fine—come on in." The seven-year war included numerous bloody battles. A correspondent described one such battle in July:[131]

Fifty planes took the air, loaded down with bombs. Making repeated trips between the bomb supply station and the enemy areas, they dropped thousands of pounds of explosives on Riffan positions and behind the lines. The air attack was particularly effective in the central sector against the Riffian forces which are attacking the French posts of Ain Aisha. The French pilots, swooping low through the dangerous air currents of the mountain passes, used machine guns on the Moors and broke several determined attacks. The defending garrison, manning machine guns, trench artillery, and light field pieces firing at direct range, cheered their air brothers. Several new tribal revolts south of the French line and Riffian infiltrations through the lines north of Taza contribute to the seriousness of the situation on the eastern sector, through which French divisions of reinforcements must pass on their way to the front.

Baer was among the American pilots who volunteered to help France crush Abd el-Krim. The group departed from Paris and headed to the front. Colonel Charles Sweeney of Spokane, the organizer of the squadron, noted that among the volunteers was Paul F. Baer of New Jersey, credited with eighteen Germans from the world war. Baer and the others were paid one franc daily, were issued French colonial uniforms and received commissions. But to avoid committing themselves to a five-year tour of duty in the French Foreign Legion, "they are taking service in the sultan's army, which is under French control."[132]

Clues to Baer's travels and whereabouts in the wake of the Moroccan campaign can be found in newspaper articles through the 1920s. Similar to his quest to provide every family with the Model T automobile, Henry Ford envisioned a world where average citizens also could have access to a small, affordable airplane, the Ford Flivver. The Flivver project was abandoned, but Ford's interest in aviation continued. In early 1928, Baer was hired by

the Ford airplane division in Dearborn, Michigan, where he was "employed in the experimental department."[133]

In April 1928, death eluded one of the Baer men. But in the summer, it took another. A news account in April stated that more than $15,000 in damage was caused when the "80-foot fall of an airplane on another" occurred at a Wichita airport. The pilot, "Paul F. Baer, and two passengers crashed to the ground. All escaped injury."[134] Baer's end was still to come, but four months later in June, his father's time was up:

Alvin E. Baer, aged 65, father of Paul F. Baer, famous World war flying ace and in whose honor the Fort Wayne municipal flying field has been named, died at 9:30 o'clock this morning at the home of his daughter, Mrs. Mabel Armstrong, 304 Madison street. Mr. Baer was a railroad engineer and had been employed at Mobile, Ala., until recent weeks when he took ill and returned to Fort Wayne to be with his daughter. He formerly was an engineer on the Nickel Plate [nickname for the New York, Chicago and St. Louis Railroad] *but left here a quarter of a centry* [sic] *ago. Mr. Baer was a member of Howard lodge, F.&A.M. at Mobile, and of division No. 140, B. of L.E. He formerly was a member of the Masonic fraternity of this city. Surviving are his daughter; three sons, Alvin W. and Paul F., of Los Angeles, and Arthur L. of Toronto, Can.: seven grandchildren; one brother, A.W. of Gary; one sister, Mrs. A.M. Lyon of Connellsville, Pa.; two half sisters, Mrs. Katherine Tackwell, of Fort Wayne, and Mrs. Bertha Best, of Los Angeles, and one half-brother, J.W. Baer, of Flint. Mich.*[135]

In February, Baer, now thirty-six, earned Transport Pilot License no. 1587 from the U.S. Department of Commerce, Aeronautics Branch.[136] Baer's next sojourn landed him at the United States Department of Commerce, where he was hired as an aviation examiner and assigned to the Texas district. The duties required Baer to administer aviation examinations, issue pilot licenses and inspect airplanes while enforcing all aeronautical regulations and promoting an interest in flying. In March 1929, the department assigned Baer to represent it at a dedication of the Brownsville, Texas municipal airport.

Everyone knew of Baer's wartime accomplishments and that he had a total of a dozen years' experience as a pilot, but for some reason, a local newsman still found it necessary to ask whether Baer was the right man for the job. He put his question to Major Bernard Law, president of the

A transport pilot's license, issued by the Department of Commerce Aeronautics Division, was earned by Baer in February 1930. *Paul Baer Collection, Allen County–Fort Wayne Historical Society.*

Brownsville International Aviation School and future superintendent of operations at the CAT (*Corporacion Aeronautica de Transportes*) Lines. Formerly in the army air service, Law served as commander of Ellington Field at Houston and had a dozen years in the military serving in the United States and on the western front in France:[137]

"Is Baer competent to handle his work?" was the query put to Major Bernard Law of Brownsville who has known Baer since 1916. "Competent?" the major retorted. "Baer has seen more real service with planes than any other man with whom I ever came in contact. He has lived with them for 13 years. Baer will not tell you his experiences or how he received his decorations. All that the world knows about Baer is what his friends tell and there is not a pilot in the service who is not a friend and admirer of Baer. In 1916, I was with Baer and we were doing our bit with General Pershing's expeditionary forces in Mexico. We became separated and in February 1917, Baer went to Paris and enlisted in the French Foreign Legion and was immediately assigned to the French Air Service.[138]

While in Brownsville, Baer found time to mingle socially with one aviation luminary who flew in to offer her support for the new airport:

> *Miss Amelia Earhart, the "sweetheart of aviation," who attended the two-day celebration commemorating the opening of the Brownsville airport, departed Sunday night for New York, where she is due to address the Society of Mechanical Engineers Wednesday night. During her stay in Brownsville, she was the guest of the city, and made many friends here, attending several social functions. A luncheon in her honor included Paul Frank Baer and Major Bernard Law.* [139]

Baer left the Department of Commerce to join Pan American Airways as an engineer in 1929. Pan Am was founded two years after the Air Mail Act of 1925 was passed by Congress. The new law allowed government mail contracts to be awarded to private transportation companies. The legislation prompted aircraft operators and investors to create new air carrier services and jump on board a profitable business. Pan Am won a contract from the United States Postal Service in 1927 and began flying mail between America and Cuba using a route between Key West and Havana. [140]

Baer's role at Pan Am included piloting photographic missions over new flying fields being constructed in South America. A company memo distributed in November 1929 issued instructions for everyone to cooperate with Baer, as necessary:

> *To all Concerned: This letter of identification has been given to Mr. Paul F. Baer, Engineer in this Department, to whom has been assigned the duty of making a photographic record of our airway construction work. Mr. Baer is proceeding over the airways and will arrange to do his work without causing any inconvenience or delays in operation. It is requested that Traffic representatives honor Mr. Baer's requests for transportation, subject only to there being unsold pay-load capacity available. Mr. Baer also carries a letter...which will be his authority to make requests upon operating personnel for opportunities to make a complete photographic record.* [141]

Death once again visited Baer's family, this time calling for his sister. Mabel died on the morning of May 14, 1930, at her home at 904 Madison Street in Fort Wayne. Her death certificate listed the cause of death as "cerebral apoplexy." She was forty-two years old. Mabel was buried at Lindenwood Cemetery in her hometown. [142] According to an obituary in

a Fort Wayne newspaper, her husband survived her, along with numerous family members:

> [Mabel] *was a member of Calvary United Brethren church and Ben-Hur court No. 15* [a fraternal organization]. *She was born in Chicago, but had lived here for the greater part of her life. Surviving are the husband, Arthur A. Armstrong; a daughter, Marion; four sons, Arthur L., Paul and George Armstrong, all of this city, and Wayne Armstrong of Los Angeles.*[143]

Meanwhile, as usual, Baer was not long for the world of Pan Am and his photographic flying adventures in South America. Word began to spread in the flying community that transport pilots were wanted in China. This news did not fall unheeded on Baer, and he took off for his final distant adventure.

FALLEN BIRDMAN IN SHANGHAI

O n a layover in Chicago in late September while en route to Vancouver, Baer telephoned Emma.[144] No doubt she was surprised when she learned his next destination: China. Baer was on a 2,100-mile trip to the coastal seaport to board the *Empress of Canada* on October 2, 1930, bound for Shanghai. Baer had been hired as a pilot by the recently formed China National Aviation Corporation (CNAC) to fly mail and passengers. Perhaps hearing from her wandering son pleased Emma.

But not everyone at the new airline was pleased to have him arrive. CNAC had developed an impressive safety record. Its fleet had flown nearly 400,000 miles and carried three thousand passengers injury-free since it began operating in October 1929. The airline's operation manager deserved the credit. But he had his reservations about some new replacement pilots, including Baer:

The credit for this excellent safety record belonged to the airline's flight and personnel and to the operations manager, Harry Smith. Smith and his senior pilot, Ernest Allison, were quarreling over the competence of several replacement pilots who had been sent out from the United States. Paul F. Baer was one of the new arrivals. Baer had come to China with a distinguished record. He had flown with the Lafayette Escadrille prior to America's entry into World War I, then with the 103d Pursuit Squadron. Credited with nine victories, Baer ended the war as the tenth-ranking American Ace. On the other hand, Baer had not had much commercial

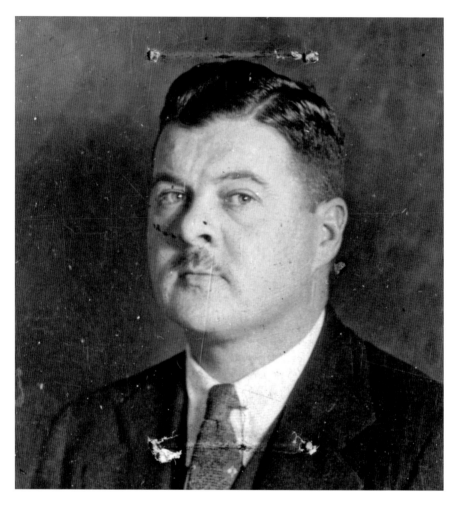

The photo that appeared on Baer's Mexican visa, issued in 1929, in connection with his assignment at Pan Am Airways. *Paul Baer Collection, Allen County–Fort Wayne Historical Society.*

flying experience. Allison "absolutely refused" to pass Baer as ready to command a Loening [an amphibious aircraft]. *Smith overruled him and placed Baer on the regular service to Hankow.*[145]

Baer's inaugural flight for the airline was a thirty-minute familiarization trip on October 28 in the Loening aircraft based at the Lung Hwa amphibious port at Shanghai. His probation period did not last long. Two days later, "he was flying the 516-mile Shanghai-Hankow run over bandit-held territory and dodging when they occasionally took pot shots at his plane. According to

Paul's flight log, he made two scheduled flights in October. All of the takeoffs and landings were on water, except at Hankow. Stops were made for fifteen minutes at Nanking and Kiukiang on the seven-hour trip."[146]

After only two months on the job at CNAC, death's clammy embrace finally caught up with Paul Baer. On the morning of December 9, 1930, Baer; his Chinese copilot, a student pilot named K.F. Pan; and four passengers boarded Baer's Loening for the scheduled trip to Hankow. All early CNAC aircraft were given names of places in China. Baer's plane was named *Shanghai*. What happened next that Tuesday morning would leave four of the souls on board the *Shanghai*, including Baer, dead within minutes:

> *Baer taxied into the center of the Whangpoo River, then began his take-off run downstream (south to north), just abeam CNAC's hangars at Lunghwa. The green-painted aircraft (green was the traditional color of the Chinese Postal service) lifted off the water and began to climb straight ahead. A crosswind caused the aircraft to drift to the left. Because of the cowling of the engine on the Loening, the pilot, who sat in the left seat, had little vision to the right and ahead. It is not known whether Baer's copilot ever saw the obstacle. In any event, the lower right wing of the aircraft, close to the fuselage, struck the top of the main mast of a large Chinese junk laying at anchor near the bank of the river. The plane flipped over on its back and plunged into the marshy river bank, upside down, at an angle of approximately 60 degrees. Baer, his copilot, and two passengers perished. The remaining two passengers, including the garrison commander of the Shanghai-Woosung district who was making his first flight, were seriously injured.[147]*

Word soon reached America. Back home, a certain irony was noted regarding the timing of Baer's demise:

> *As the first plane left Paul Baer municipal airport here on the first trip of a new air mail route today, word was received from Shanghai, China, that Paul Frank Baer, a ranking American ace during the world war, for whom the local airport was named, crashed to his death while flying the Chinese air mail between Shanghai and Hankow. Baer's mother, Mrs. Emma Shroyer, who lives here, had not seen her son for several years.[148]*

In Texas, news accounts fondly recalled Baer's service as a Department of Commerce inspector and the impression he made while there: "Paul Baer,

36, formerly Department of Commerce aeronautics inspector stationed here, died in an airplane crash at Shanghai, China, Tuesday. He was here in 1927 and 1928. He also visited here in 1929 and had many friends in the city. Baer had been working for the China National Aviation Corporation, owner of the plane, only two months, according to an Associated Press dispatch telling of the crash."[149]

Numerous citizens recalled Baer's days in Texas. J. Wayne Parks, manager of Winburn Field near San Antonio, recounted the circumstances that brought Baer to Texas while he was working at the commerce department: "Baer was assigned here to take the place of 'Shorty' Cramer as Commerce Department inspector. Cramer was lost in Greenland on an Arctic flight in 1927. From here, Baer went to South America, where he was employed as a commercial pilot, remaining there about a year."[150]

San Antonio architect A.T. Phelps told a newspaper reporter that Baer was a frequent visitor at his home when he came to the city in 1929. Phelps expressed surprise upon learning that Baer had died in a crash while at the controls of a plane because Baer "had more than 3,500 flying hours to his credit…and [Phelps] had never heard of Baer having had a previous accident." Phelps's son and Baer were friends.[151]

Perhaps it was A.T. Jr. who steered his friend Baer to Pan Am. The architect's son was "at that time a pilot here but later went to Vera Cruz [Mexico] as a pilot for the Pan American Airways."[152]

John Sanderson, CNAC secretary based in New York, arranged for Baer's body to be returned to the United States on a private ship. Mr. Sanderson telephoned Baer's mother from New York, assuring her that every effort to return her son's body as soon as possible would be undertaken and that proper escort would be arranged. It would take about three or four weeks to complete the trip, Sanderson told Emma.[153]

Baer's body arrived in Washington State on December 27 and left Seattle by train for Fort Wayne, where the American Legion was already at work planning an elaborate military funeral. In Seattle, Legionnaires, regular soldiers from Fort Lawton and Air Corps Reserve officers escorted Baer's body on a horse-drawn caisson (a cart used to bear the casket of the deceased in a military funeral) from the steamship *President McKinley* to the train.[154]

There may have been poetic justice in the fact that in his death, as it had been in his life, Baer would be absent from the seminal event meant to honor him. It didn't take long for newspapers to explain and try to rationalize this:

Lieutenant Baer, a hero whose modesty equaled his greatness, was being memorialized by the proud city of his birth, a city which knew of his deeds but because of his taciturnity, little of himself. When his native city gave his name to its airport in a pretentious public ceremony, Paul Baer avoided acceptance of the invitation to be present. It was an honor he appreciated but such honors were incompatible with his sense of reserve. He found excuses. He was not able to be present. Later when the activities of the airport had assumed the hum of daily routine, Baer visited it, expressed pride in the fact that it bore his name, but again refused the public recognition which well-wishers sought to give him. Baer was one of the modern adventurers, whose deeds pale the storied soldiers of fortune of the past. His career was in the air, an unconquerable element to the warriors of the past. In defense of country and pursuit of foe, he had soared in war time over England, France, Belgium and Germany. Home again after the war, his record was as stirring in the less spectacular affairs of peace. Ever the adventurer he became also the pioneer. He carried out the research ideas of great aeronautical laboratories at Detroit and risked his life in the daily experiments. With things accomplished there, he again served his government as an inspector in the aeronautics branch of the Department of Commerce, enforcing the rules and regulations which his nation imposed to make flying safer. This occupation proved a bit too monotonous so he went to South America to open air mail routes. [155]

Another paper explained Baer's shyness this way to its readers:

The man who sent 18 enemy planes crashing to earth and won the highest honors of two great nations was memorialized by the proud city of his birth, a city which knew of his deeds but because of his taciturnity, little of himself. When his native city gave his name to its airport in a pretentious public ceremony, Paul Baer avoided acceptance of the invitation to be present. It was an honor he appreciated by such honors were incompatible with his sense of reserve. He found excuses. He was not able to be present. Later when the activities of the airport had assumed the hum of daily routine, Baer visited it, expressed pride in the fact that it bore his name, but again refused the public recognition which well wishers sought to give him. [156]

A local group of who's who and VIPs was assembled to plan Baer's funeral. Members of the planning committee were announced by J.B. Wiles,

manager and industrial commissioner of the Fort Wayne Chamber of Commerce:

> *The committee included: Paul C. Guild, of the aviation committee of the Chamber of Commerce; Arthur F. Hall, of the board of aviation commissioners; Fort Wayne Mayor W.J. Hosey; Fred George, of the National Aeronautic Association's chapter here; Capt. Robert Bartel, of Paul Baer Municipal Airport; Capt. Clarence F. Cornish, of the Guy Means Airport; Verne Gingher, of the American Legion Post No. 47; James Baker, also of the legion post; George Gatchell representing the flier's family; Mr. Wiles and Carl Hauck, undertaker.* [157]

U.S. Representative David Hogg (R-Ind.) arranged for a local artillery company to participate in the funeral and march ahead of Baer's body, which would be carried on a caisson. The planning committee extended invitations to Captain Eddie Rickenbacker and other famous American war heroes, as well as to General John J. Pershing, head of the AEF during the war. The whole city was asked to show its support. Business houses and industries of the city were asked to fly flags at half-mast on the day of the funeral. Merchants downtown were asked to display their curb flags and drape them with crepe. [158]

Plans called for Baer's remains to be met at the train by an American Legion guard of honor and brought to the Carl Hauck Funeral Home, 2218 South Calhoun Street. The body would then be taken to Emma's house on south Anthony Boulevard.

It seemed that everyone wanted to play a role in the final send-off of their hometown hero. George W. Hill, pilot of the Thompson Aeronautic Corporation, offered to provide any airplanes the planners required. Reverend B.E. Rediger, of the Rediger Tabernacle, emerged as the officiant for the funeral services. Baer's final resting place would be Lindenwood Cemetery. The organizing committee announced plans for Baer's body to lie in state for several days at a public place, the Allen County Courthouse, where nearly twenty thousand people would file past him to pay respects. [159]

Planners invited and hoped that representatives of the U.S. War Department would attend Baer's funeral. Efforts were made to ensure that army planes from Selfridge Field at Mount Clemens, Michigan, participated in the funeral rites. [160]

Eight army pilots from the 1st Pursuit Group attended and served as honorary pallbearers, bringing the company's colors for display. "While the

eight pilots marched as pallbearers, six of their comrades from the same group flew over the cortege downtown and dropped wreaths over the flier's grave at Lindenwood." The planes dipped their wings as they passed over the funeral cortege (procession).[161]

At the Fort Wayne Gospel Temple on East Rudisill Boulevard, Reverend E.B. Rediger stepped to the podium before a packed tabernacle:

After saying a prayer, the minister gave a short sketch of the manner of Baer's death, after which the temple male quartet sang, "Beautiful Isle of Somewhere." After the quartet's first selection, the Rev. Mr. Rediger discussed the dead airman's career and told of the moral precepts that may be drawn from the religious influences in life. He praised Mrs. Shroyer, the mother of Paul Baer for having given him the gift of religious faith. He pointed out the assurances of man's mortality and the immortality of the soul. The sermon was closed with the minister asking God's blessings on the relatives of Paul Baer, those present and the soul of Baer. Following the song, "Soldier Rest," the casket was rolled out of the tabernacle and placed in the hearse.[162]

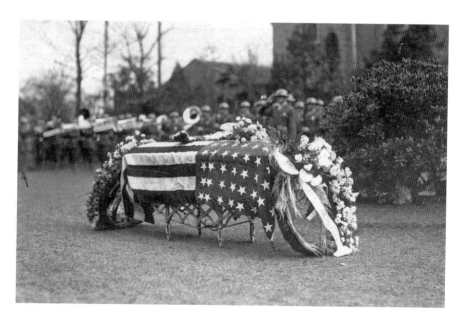

In Shanghai, military services honored the deceased ace before his body was returned to the United States. *Paul Baer Collection, Allen County–Fort Wayne Historical Society.*

All in all, Baer's funeral was the largest and most elaborate of its kind ever seen in Fort Wayne.[163] A local newspaper account compared it to the 1901 funeral of Civil War veteran and Indianapolis lawyer Benjamin Harrison, the twenty-third president of the United States:

The funeral was probably attended by the largest crowd of any funeral ever held here. The details of the obsequies were probably the most comprehensive since the funeral at Indianapolis many years ago of President Benjamin Harrison. Thousands of persons lined the route of the funeral cortege Saturday afternoon. Rows of persons, three or four deep, stood on both sides of the line of march from the Fort Wayne Gospel Temple on East Rudisill Boulevard to Lindenwood Cemetery, where thousands of other persons congregated. There was not a single break in the line of persons from the tabernacle to the cemetery.[164]

Those who could not attend in person could also follow the proceedings via radio. Members of Baer's funeral committee arranged for the entire event to be broadcast on station WOWO ("Wayne Offers Wonderful Opportunities") AM 1190:

Plans have been made…to have the services at the tabernacle, the procession and the military service at Lindenwood cemetery broadcast from radio station WOWO. According to officials at the station, the broadcast will start at 11:50 o'clock this morning and will continue until the services are completed. Attorney Samuel Jackson will be in charge of the announcing, and will give radio listeners a description of the services, the parade and the military rites at the cemetery. Several microphones have been placed along the route of the funeral march, and others are set up at the tabernacle and in the cemetery.[165]

Media coverage was not limited to radio and print, and the news of Baer's death generated national, even international, interest. "Representatives of both the Pathe News [British Pathé] and Fox News Reel companies" were in Fort Wayne "to take motion pictures of the funeral procession and services at the grave."[166]

Even the legal system ground to a halt to mark Baer's passing. "All three major courts of Allen county adjourned sessions…as a tribute to Paul Baer whose casket lay in state with a military guard on the ground floor of the courthouse beneath the lofty glass dome of the building." The order to adjourn, issued by Judge George H. Leonard, included the following eulogy:

That great and distinguished soldier and aviator, Lieut. Paul F. Baer, having been called to the great beyond through death, marks the passing of one long to be remembered. A true patriot and exemplary citizen, who regarded human life a sacred thing, but who gave his best in line of duty during the World war, and his all thereafter to the advancement of aviation. He represented the highest type of American manhood, typifying the true spirit of the cream of our nations, soldiers, aviators, and sailors, who answered the call at the time of our country's greatest need, and as a tribute to him now lies in state in this courthouse and to his memory, court is now adjourned at 1:30 p.m., and this tribute is ordered spread of record on the order books of this court.[167]

Overhead, dozens of airplanes offered fly-by salutes, dipping their wings as they passed over the cortege. The crowd included a mix of Americans from all walks: politicians, military local dignitaries, some of Baer's former colleagues at the Department of Commerce, businessmen, retired fighter pilots—including four survivors from the *Lafayette Escadrille*—and average folks:

Sorrowing home folk joined with air fighting buddies of the world war, and representatives of the state of Indiana and the American government here late Saturday in paying final tribute to the memory of Lieutenant Paul F. Baer, American world war ace and Indiana hero of the great conflict…with numerous decorations for bravery gracing his flag-draped coffin, men who lived with him through the fiercest fighting of the world war, paid simple tribute to their buddy who led in being the first of all American flyers to win the highly prized honor of being an ace. His body, mounted on a caisson, and followed by a detachment of infantrymen, sent from Ft. Benjamin Harrison at the special request of Patrick J. Hurley, Secretary of War, was borne through the streets of his home town, while more than a score of United States army, department of commerce, and civilian planes soared above the cortege. Four of the survivors of the famed Lafayette Escadrille in which Baer was a captain before America's entry into the war, attended the funeral. They were Donald Eldredge, South Bend; Thomas Cassady and George Mosely, Chicago; and Frederick W. Zinn, Battle Creek, Mich. They carried the original colors of the famous air fighting unit in the funeral procession. Six members of the aeronautics branch of the United States Department of Commerce, with whom Baer was formerly associated, were present at the rites. [Baer] was shot down and made a prisoner when he

made a futile effort to save the life of Lieut. Ernest Jerioux, French flyer,
attacked by enemy planes. A basket of red roses sent by the mother of
Jerioux occupied a prominent place among the floral offerings sent by friends
and official dignitaries from all parts of the country.[168]

In the small town of Garrett, located about thirty minutes north of Fort
Wayne, the town newspaper recapped Baer's career in a story about the
funeral activities, calling him "a modern adventurer" and still fretting about
how hard it was to get the taciturn hero to talk about himself for the record:

The city in which he was born and the nation whose escutcheon [coat of
arms] he gloriously inscribed with deeds of valor in the greatest conflict in
the history of the world were today paying their last honors to Lieut. Paul
Frank Baer, the first American to become a World War ace and the first
American airman in the World war to win a Distinguished Service Cross.
Lieutenant Baer, a hero whose modesty equaled his greatness, was being laid
to rest. The quiet, always reserved youth, who pursued Villa, the bandit
with Pershing to Mexican hills in 1916; who worked his way as hostler
on a boat in order to fight in France with the Lafayette Escadrille; who
transferred to the American Flying Corps when this nation entered the war
and who fell a prisoner in Germany while attempting futilely to save the life
of a French comrade, was providing the material for the final chapter of a
hero's biography. The man who sent 18 enemy planes crashing to the earth
and won the highest honors of two great nations was being memorialized by
the proud city of his birth, a city which knew of his deeds but because of
his taciturnity, little of himself. When his native city gave his name to its
airport in a pretentious public ceremony, Paul Baer avoided acceptance of
the invitation to be present. It was an honor he appreciated but such honors
were incompatible with his sense of reserve. He found excuses. He was not
able to be present. Later when the activities of the airport had assumed the
hum of daily routine, Baer visited it, expressed pride in the fact that it bore
his name, but again refused the public recognition which well wishers sought
to give him. Baer was one of the modern adventurers, whose deeds pale
the storied soldiers of fortune. His career was in the air, an unconquerable
element to the warriors of the past. In defense of country and pursuit of foe,
he had soared in war time over England, France, Belgium and Germany.
Home again after the war, his record was as stirring in the less spectacular
affairs of peace. Ever the adventurer he became also the pioneer. He carried
out the research ideas of great aeronautical laboratories at Detroit and

risked his life in daily experiments. With things accomplished there, he again served his government as an inspector in the aeronautics branch of the Department of Commerce, enforcing the rules and regulations which his nation imposed to make flying safer. This occupation proved a bit too monotonous so he went to South America to open air mail lines. It was…in another far-off country that death whom he had so many times vanquished before overtook him.[169]

The local press continued to struggle to find ways to justify its adoring coverage of the hesitant hero and headlines like "Pomp Marks Baer Funeral." One put it this way: "Well deserved honors from which he shrank during his life were yesterday accorded to Lieut. Paul Frank Baer, Fort Wayne's famous son of the World war." And, as if to provide a more likeable and human side of Baer, the paper found a former colleague at the Department of Commerce who "told of receiving a Christmas card mailed to him from China by Paul Baer."[170]

Baer's body finally arrived at the cemetery, where the strains of mournful music fell on a large gathering:

Thousands of people crowded the cemetery where Baer was to be put to rest. To the strains of Chopin's funeral march the procession slowly marched down the winding road to where Lieut. Baer's grave had been prepared. Automobiles bearing the mourners had taken another route and were waiting at the grave. The dead ace's mother, Mrs. Emma Shroyer, escorted by her husband, had been taken to a place of honor as the body was carried to the grave by the officers who served as pallbearers.[171]

In the same article, for reasons unreported, it was noted that Baer's two brothers were unable to attend the service. Baer's body was laid to rest on a gentle slope at Lindenwood Cemetery in Fort Wayne after the ceremonial procession of a caisson of the 3rd U.S. Field Artillery. A salute was fired over the grave by a detachment of the 11th U.S. infantry from Fort Benjamin Harrison, a U.S. Army base that was located northeast of Indianapolis.[172]

A few weeks later, Emma Shroyer applied for a headstone from the U.S. War Department on February 4, 1931.[173] The stone was shipped on April 22 and installed shortly thereafter at Lindenwood.

At the top of the gravestone, an image of the Lafayette Flying Corps Medal is stamped on the stone. The medal features the words "Lafayette Flying Corps" printed in an arch above a star, under which an eagle with

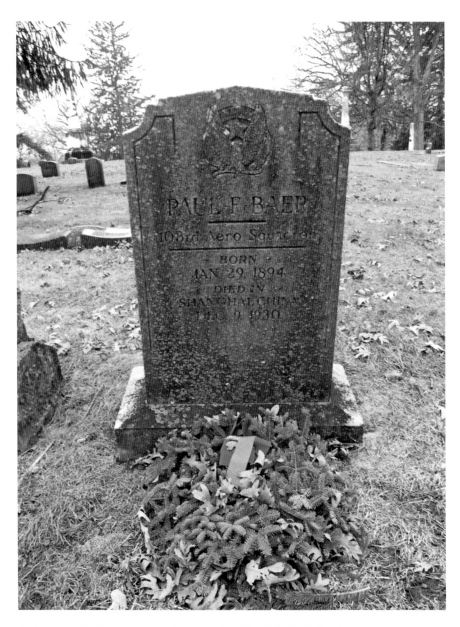

A picture of Baer's gravestone as it appeared in March 2017. *Author photo.*

Shortly after her son's death, Emma Shroyer applied for a headstone from the War Department for Baer's grave. *U.S. Headstone Applications for Military Veterans (1925–63), ancestry.com.*

upraised wings holds a bent propeller (the pilots called them "pranged"), followed by these words:

PAUL F. BAER
103d Aero Squadron
BORN
JAN. 29, 1894
DIED IN
SHANGHAI, CHINA
Dec. 9, 1930

Emma outlived her son Paul by another two decades. In 1954, widowed for fourteen years from her third and last husband, Martin Shroyer, Emma died from lung cancer on Sunday, September 5, in the Lawton Nursing Home on Clinton Street in Fort Wayne. A simple obituary in the local newspaper noted that "her second husband, Martin D. Shroyer, died in 1940." Emma's "body was taken to the Challant-Perry Funeral Home, where friends may call after 7 p.m."[174] Emma was buried four days later near her son at Lindenwood Cemetery.

POSTSCRIPT

No one knows if Paul Baer secretly went to his grave hoping that someone—someday—would set the record straight that he was the first American to shoot down an enemy plane in combat, the first to be named an ace for shooting down five and the first American to be awarded the Distinguished Service Cross. Probably not, given his incessant need to just move on and leave the past alone. But someone eventually did set the record straight. It was Clifford J. Milnor, who grew up in rural Rome City in northeast Indiana about thirty-six miles north of Fort Wayne.

Like many small towns, Rome City is not much to write home about. But in fairness, it does have some bragging rights to Ford Frick, who attended high school there. Baseball fans will recognize his name because he served as commissioner of Major League Baseball from 1951 to 1965.

Milnor graduated from Indiana University and went on to work as a copy editor and city editor, as well as columnist. He did a stint at the *Goshen Daily Democrat* before joining the *Fort Wayne Journal-Gazette* in 1933. In 1945, Milnor created the column "Lines and Angles," which became one of the *Fort Wayne Journal-Gazette*'s most popular features. "Lines and Angles" served "in part as a clearing house for local and area human interest stories."[175] In 1966, in response to a letter from a Fort Wayne resident, Milnor offered his column's pulpit as a platform to bring new and credible evidence that Baer, indeed, had been America's first ace. Under the headline, "Now It's Settled?" Milnor wrote:

Willian [the spelling in original article] *T. White, 3710 S. Washington Road, likes to keep facts straight. On June 5 he saw a picture of four World War I aces in* The Journal-Gazette *which puzzled him. They were Charles D'Olive, Eddie Rickenbacker, Reed Chambers and Douglas Campbell, described as the first ace. He wrote the Air Force Museum Foundation at Wright-Patterson AFB to inquire what happened to Paul Baer, Fort Wayne's WWI ace. "Why wasn't Baer named? I have been under the impression." wrote Bill, "that Baer, in whose honor our local field was named, was one of the three great aces and the first one."*[176]

At the time, the chief of the research division of the Air Force Museum Foundation was a man named Royal D. Frey Jr., originally from Columbus, Ohio. As a second lieutenant in World War II, Frey flew the twin-tailed P-38 Lightning fighter in Europe, scoring two victories before being shot down and taken as a prisoner of war by the Germans. He and Baer had that in common, and there was no fight from Frey regarding Baer's status as America's first combat ace. Frey replied to Mr. White quickly:

You are absolutely correct in your belief that Lt. Paul Baer was the first member of the U.S. Air Service to become an ace in World War I by obtaining five confirmed aerial victories over enemy aircraft....However, he was trained by the French and subsequently flew with the 103d Aero Squadron. The 103d was originally the Lafayette Escadrille and, as such, it was part of the French Air Service. On 18 February 1918, the squadron was transferred to the U.S. Air Service and became the 103d Aero Squadron. However, it remained with the French Air Service for several months, even though it was now a U.S. squadron, and it flew combat on the French front.... The 94th Aero Squadron began flying combat missions from Toul over the "American front" in April, 1918.... Unfortunately, few men in the Toul area knew of the 103d and the fact it had been flying with the French for several months a hundred miles or so to the northwest, and Lt. Baer's accomplishments went unnoticed by the war correspondents at Toul. Consequently, when Campbell got his fifth victory he was hailed by the press as the first U.S. ace. In summary, Baer was the first man in U.S. uniform to become an ace, although he was trained by the French and he got his first five victories over the French front. Campbell was the first man in U.S. uniform to become an ace on the American front; he was also the first pilot trained at flying schools

operated by the U.S. Air Service to become an ace. Despite all these circumstances, you are still correct. Baer was definitely the first U.S. Air service pilot to become an ace in World War I!

Milnor thought the U.S. Air Force waffled in its answer and rephrased Frey's correspondence with this conclusion: "Thus, the Air Force Museum Foundation firmly takes its straddle position. Paul Baer was the first American ace, but he shot the enemy planes down in the wrong places. Unfortunately for Baer, he met death in a plane mishap in China in the early 1930s. Had he lived, his legend probably would have grown with him."

So would, undoubtedly, his efforts to continue to evade any and all publicity in the process. After his death, Baer's name did not sit still for long on any edifice. The attempt to name a local airport in his honor followed a meandering path that mirrored the nomadic progression of Baer's career. It is as if his very name, like Baer himself, could not sit still.

Operations at Baer Field began in 1925. Located on 236 acres of land nearly five miles north of downtown Fort Wayne, it was the city's first municipal airport. Construction followed efforts by local park board officials to obtain the rights to the land.

Nearly sixteen years later, Baer's name was on the move. In preparation for the outbreak of World War II, the federal government leased a seven-hundred-acre site south of the city to serve as a training field for the U.S. Army Air Force. War Department policy required military airports be named after a military figure. The army named its new airfield Baer Field.

Meanwhile, the original Baer Field was rededicated as Smith Field, in honor of Fort Wayne aviation pioneer Art Smith. Nicknamed "Bird Boy," the Fort Wayne native enjoyed a successful career as a test pilot, flight instructor, airmail pilot and stunt pilot until he was killed in a crash.[177]

After World War II ended, the government sold Baer Field to the City of Fort Wayne for one dollar. Baer's name was dropped, and the field was christened with a new moniker: Fort Wayne Municipal Airport. That name was changed in 1991 to Fort Wayne International Airport.

Whether Baer—or his surname—likes it or not, the 1991 airport renaming included an attempt to find a permanent home honoring Baer's memory. The airport's terminal is named after the "Forgotten Falcon of Fort Wayne."

IN THEIR HONOR

F ollowing are remarks by David Lloyd George (British politician and statesman), delivered to the House of Commons, October 29, 1917.[178]

Far above the squalor and the mud, so high in the firmament as to be invisible from earth, they fight out the eternal issues of right and wrong. Their daily and nightly struggles are like Miltonic conflicts between winged hosts. They fight high and low. They skim like armed swallows along the Front, attacking men in their flights, armed with rifle and machine gun. They scatter infantry on the march; they destroy convoys; they wreck trains. Every fight is a romance, every record an epic. They are the knighthood of this war, without fear and without reproach, and they recall the legendary days of chivalry, not merely by the daring of their exploits, but by the nobility of their spirit.

NOTES

Introduction

1. Laurence La Tourette Driggs, *Heroes of Aviation* (Boston: Little, Brown and Company, 1919), 18.
2. United States Air Force (USAF), "Global Vigilance, Global Reach, Global Power for America," www.af.mil.

Chapter 1

3. On This Day, "Historical Events in 1866," www.onthisday.com.
4. Ancestry.com, "1870 United States Federal Census," www.ancestry.com.
5. Ibid., "Baer & Parent Marriage Certificate," www.ancestry.com.
6. *Fort Wayne Daily News*, "Local Courts," November 24, 1906, newspapers.com.
7. Ancestry.com, "1910 U.S. Federal Census for Frederick E. Dyer," www.ancestry.com.
8. Herb Harnish, *Paul Baer Scrapbook*, vol. 31, no. 4 (Fort Wayne, IN: Allen County–Fort Wayne Historical Society, 1968).
9. Ibid.
10. Indiana Historical Society, "Fort Wayne News-Sentinel," www.history.org.
11. *Indianapolis Star*, "Hoosier Flier Tells His Father About Beating Off Many Huns," April 30, 1918, ProQuest Historical Newspapers.
12. Tim Hrenchir, "State History: 8 Events that Shaped Indiana," NewsMax, February 23, 2015, http://www.newsmax.com.

13. *Indianapolis News*, "Aviator Who Brought Down German Plane Is a Hoosier," March 20, 1918, newspapers.com.

14. Harnish, *Paul Baer Scrapbook*, vol. 31, no. 4, 5.

15. *Fort Wayne News*, "More Divorce Complaints," November 26, 1914, newspapers.com.

16. Harnish, *Paul Baer Scrapbook*, vol. 31, no. 4, 5.

17. Ibid.

18. *Fort Wayne News*, "Eleven Americans Are Shot Down," March 9, 1916, newspapers.com.

19. Ibid.

20. U.S. Army Center of Military History, "Mexican Expedition," www.history.army/mil.

21. Harnish, *Paul Baer Scrapbook*, vol. 31, no. 4, 6.

22. Ibid.

23. Indiana National Guard, "Indiana National Guard History," https://www.in.ng.mil/AboutUs/History.aspx.

Chapter 2

24. James Norman Hall and Charles Bernard Nordhoff, *The Lafayette Flying Corps*, vol. 1 (Boston: Houghton Mifflin Company, 1920), 3.

25. *Junction City Daily Union*, "Lafayette Flying Corps," December 1, 1917, newspapers.com.

26. U.S. Air Force Historical Research Agency, "U.S. Air Service Victory Credits, World War I," www.afhra.af.mil/information/studies.

27. Rear Admiral Edwin C. Parsons, *I Flew with the Lafayette Escadrille* (Sevenoaks, UK: Pickle Partners Publishing, 2016), 32.

28. Ibid.

29. La Tourette Driggs, *Heroes of Aviation*, 2.

30. *Indianapolis News*, "Aviator Who Brought Down German Plane."

31. Ancestry.com, "Paul Frank Baer, U.S. Passport Applications (1795–1925)," www.ancestry.com.

32. Hall and Nordhoff, *Lafayette Flying Corps*, vol. 1, 10.

33. Dennis Gordon, *The Lafayette Flying Corps* (Atglen, PA: Schiffer Military History, 2000), 6.

34. Ibid., 7.

35. Parsons, *I Flew with the Lafayette Escadrille*, 70.

36. Gordon, *Lafayette Flying Corps*, 11.

37. Hall and Nordhoff, *Lafayette Flying Corps*, vol. 2, 12.
38. Parsons, *I Flew with the Lafayette Escadrille*, 26.
39. Ibid., 66.
40. Gordon, *Lafayette Flying Corps*, 11.
41. Parsons, *I Flew with the Lafayette Escadrille*, 68.
42. Gordon, *Lafayette Flying Corps*, 12.
43. Harnish, *Paul Baer Scrapbook*, vol. 31, no. 4, 9.
44. Gordon, *Lafayette Flying Corps*, 12.
45. Hall and Nordhoff, *Lafayette Flying Corps*, vol. 1, 299.
46. Parsons, *I Flew with the Lafayette Escadrille*, 68.
47. Gordon, *Lafayette Flying Corps*, 13.
48. Ibid.
49. Harnish, *Paul Baer Scrapbook*, vol. 31, no. 4, 7.
50. Gordon, *Lafayette Flying Corps*, 15.
51. *Century of Flight*, Time-Life Books (Alexandria, VA: Time-Life Inc., 1999), 47.
52. *Indianapolis Star*, "Hoosier Flyer Tells His Father."
53. Ancestry.com, "Arthur L. Baer & Alvin Webster Baer, U.S. World War I Draft Registration Cards," www.ancestry.com.
54. Harnish, *Paul Baer Scrapbook*, vol. 31, no. 4, 8.

Chapter 3

55. U.S. Centennial of Flight Commission, "Louis Bleriot," www.centennialofflight.net.
56. Hall and Nordhoff, *Lafayette Flying Corps*, vol. 1, 490.
57. Ibid., 126–27.
58. Harnish, *Paul Baer Scrapbook*, vol. 31, no. 4, 14.
59. Ibid., 12.
60. Ibid., 18.
61. Ibid., 12.
62. *Fort Wayne News and Sentinel*, "Ft. Wayne Airman," March 15, 1918, ProQuest Historical Newspapers.
63. Ibid., "'In the Fight' Says Baer," May 20, 1918, ProQuest Historical Newspapers.
64. Harnish, *Paul Baer Scrapbook*, vol. 31, no. 4, 18.
65. *Nashville Tennessean*, "Mobile Boy Has Won His Ace," May 4, 1918, ProQuest Historical Newspapers.

66. *Indianapolis Star*, "Hoosier Flier Tells His Father," April 29, 1918.

67. Gordon, *Lafayette Flying Corps*, 109.

68. Britannica Encyclopedia, "Croix de Guerre," www.britannica.com.

69. Military Times, "Hall of Valor," www.militarytimes.com.

70. Eddie Rickenbacker, *Fighting the Flying Circus* (New York: Frederick A. Stokes Company, 1919), 244–45.

Chapter 4

71. Gordon, *Lafayette Flying Corps*, 104–5.

72. Ibid.

73. Ibid.

74. Harnish, *Paul Baer Scrapbook*, vol. 31, no. 4, 17.

75. Ibid., 16.

76. Hall and Nordhoff, *Lafayette Flying Corps*, vol. 1, 105.

77. Ibid.

78. *Chicago Tribune*, "Lieut. Paul Baer Missing: May Be Held by Foe," May 28, 1918, ProQuest Historical Newspapers.

79. *Daily Arkansas Gazette*, "U.S. Air Hero Is Prisoner of Huns," June 17, 1918, newspapers.com.

80. *Fort Wayne News and Sentinel*, "Paul Baer in Need of Food," August 30, 1918, ProQuest Historical Newspapers.

81. Ibid., "Paul Baer Was Downed by Shot," September 5, 1918, ProQuest Historical Newspapers.

82. Ibid.

83. Harnish, *Paul Baer Scrapbook*, vol. 31, no. 4, 17.

84. *Fort Wayne Journal-Gazette*, "First Lieutenant Paul Frank Baer," December 12, 1918, newspapers.com.

85. Ibid., "Greet Paul Baer This Afternoon," February 27, 1919, newspapers.com.

86. Ibid.

87. Ibid.

88. *Fort Wayne Sentinel*, "Paul Baer Is Free," December 12, 1918, newspapers.com.

89. Ibid., "Dinner Given at Noon by the Rotary Club," February 27, 1919, newspapers.com.

90. *Fort Wayne Journal-Gazette*, "Fort Wayne Ace at Rickenbacker Dinner Addressed by Baker," February 5, 1919, ProQuest Historical Newspapers.

91. *Fort Wayne Sentinel*, "Fort Wayne Will Greet Paul Baer Wednesday," February 25, 1919, newspapers.com.

92. The Great War Society, "Doughboy Center: The Story of the American Expeditionary Forces," www.worldwar1.com.

93. *Fort Wayne Journal-Gazette*, "Fort Wayne Honors Today Indiana's Premier Ace," February 27, 1919, newspapers.com.

94. *Fort Wayne News and Sentinel*, "Page Eight," February 27, 1919, newspapers. com.

Chapter 5

95. *Fort Wayne News-Sentinel*, "Baer in Letter to Chum Told of Last Air Combat," May 20, 1931, Allen County Library Genealogy Department Microfilm.

96. A photocopy of this undated letter from Paul resides in the Paul Baer Collection, Allen County–Fort Wayne Historical Society. The letter includes a handwritten note that reads, "Jim: Use your own judgment with this—and be sure to return it to me. Best wishes, Baer." The letter, circa 1919, is typed on American Flying Club stationery, 11 East Thirty-Eighth Street, New York. Baer was an active member of this organization after the war.

Chapter 6

97. *Fort Wayne Sentinel*, "Page Eight," February 27, 1919, newspapers.com.

98. *Fort Wayne Journal-Gazette*, "Give Reception for Paul Baer," February 25, 1919, newspapers.com.

99. Ibid.

100. *Fort Wayne Sentinel*, "Page 12," February 28, 1919, newspapers.com.

101. Ibid., "Dinner Given at Noon," February 27, 1919, newspapers.com.

102. *Muncie Star Press*, "Lieut. Paul F. Baer Is Welcomed at Ft. Wayne," March 1, 1919, newspapers.com.

103. *Fort Wayne Journal-Gazette*, "Gave Glad Hand to Lieut. Baer," February 28, 1919, newspapers.com.

104. Ibid.

105. Ibid.

106. Ibid.

107. Ibid.

Chapter 7

108. *New York Herald*, "American Flying Club, Two Months Old, 700 Strong, Aims High," April 27, 1919, newspapers.com.

109. *Evening World*, "Elsie Janis Cuts Cake," June 4, 1919, newspaperarchives. com.

110. Harnish, *Paul Baer Scrapbook*, vol. 31, no. 4, 26.

111. HistoryNet, "Polish-Soviet War," www.historynet.com.

112. *Fort Wayne Sentinel*, "Lieut. Paul Baer Goes to Poland," October 4, 1919, newspapers.com.

113. Ibid.

114. *Washington Times*, "U.S. Air Fleet Will Aid Poles," October 23, 1919, newspapers.com.

115. *Fort Wayne Journal-Gazette*, "Lieut. Baer Awarded the Croix de Guerre," October 4, 1919, newspapers.com.

116. *New York Times*, "War Chance for Aviators," November 9, 1919, newspapers.com.

117. *Fort Wayne Journal-Gazette*, "Will Help Poland Win Liberty," November 23, 1919, newspapers.com.

118. *Evening World*, "Aviators Flocking Here by Air Routes for Reunion Feast," November 11, 1919, newspapers.com.

119. *Fort Wayne News and Sentinel*, "Paul Baer Wishes Fort Wayne a Merry Xmas," December 24, 1919, newspapers.com.

Chapter 8

120. *Greenville News*, "American d'Artagnan of the Air Forming Squadron of Tried U.S. Fliers," January 15, 1920, newspaperarchive.com.

Chapter 9

121. Ancestry.com, "Martin D. Shroyer, Michigan Marriage Records, 1867–1952," www.ancestry.com.

122. *Mexia Evening News*, "Mexia Is Home of Many Heroes of World War," October 21, 1922, newspapers.com.

123. *Muncie Star-Press*, "Aviation Field Is Dedicated," June 26, 1925, newspapers.com.

124. *Fort Wayne News-Sentinel*, "Ceremony Held at Baer Field," June 25, 1925, Allen County Library Genealogy Department Microfilm.
125. Ibid., "Noted Flyers Here for Dedication Program at Baer Field Yesterday," June 26, 1925, Allen County Library Genealogy Department Microfilm.
126. Ibid.
127. Harnish, *Paul Baer Scrapbook*, vol. 31, no. 4, 26.
128. "Telegram to Baer," from an unsourced newspaper clip in Carl D. Gable's *Tibbet's of: WWI Fighter Flying Ace Who Did His Duty*, Allen County–Fort Wayne Public Library, call no. Gc929.2 B1448g, vol. 1.
129. "Lieut. Paul Frank Baer," an unsourced newspaper clip from Carl D. Gable's *Tibbet's of: WWI Fighter Flying Ace Who Did His Duty*.
130. Carl D. Gable's *Tibbet's of: WWI Fighter Flying Ace Who Did His Duty*.
131. Floyd Gibbons, "Yanks Coming! Cheers French in Riff Drive," *Chicago Tribune*, July 17, 1925, newspapers.com.
132. Ibid.
133. *Muncie Evening Press*, "Paul Frank Baer, Son of Emma Shroyer," February 7, 1928, newspapers.com.
134. *Wichita Daily Times*, "$15,000 Damage After Crash at Air Field," April 24, 1928, newspapers.com.
135. *Fort Wayne Evening News Sentinel*, "Alvin E. Baer Is Dead. Was Father of Paul F. Baer, Famous War Aviator," June 28, 1928, Allen County Library Genealogy Department Microfilm.
136. Harnish, *Paul Baer Scrapbook*, vol. 31, no. 8, 27.
137. *Brownsville Herald*, "Border Draws Noted Pilots," March 8, 1929, newspapers.com.
138. Ibid., "First U.S. Ace Inspects Port," March 8, 1929, newspapers.com.
139. Ibid., "Great Future for Port Is Forecast by Miss Earhart," March 12, 1929, Newspapers. com.
140. Aviation Online Magazine, "History of Pan American World Airways," www.avstop.com.
141. Memo from L.L. Odell, "To All Concerned," November 26, 1929, typed on Pan American Airways Inc. stationery, Miami, Florida, Paul Baer Collection, Allen County–Fort Wayne Historical Society.
142. Ancestry.com, "Mabel Naomi Armstrong, Indiana Death Certificates," www.ancestry.com.
143. "Baer's Sister Dies," an unsourced newspaper clip from Carl D. Gable's *Tibbet's of: WWI Fighter Flying Ace Who Did His Duty*.

Chapter 10

144. Harnish, *Paul Baer Scrapbook*, vol. 31, no. 8, 27.

145. M. O'Leary William Jr., *The Dragon's Wings: The China National Aviation Corporation and the Development of Commercial Aviation in China* (Athens: University of Georgia Press, 1976), 41.

146. Harnish, *Paul Baer Scrapbook*, vol. 31, no. 4, 26–27.

147. O'Leary, *Dragon's Wings*, 42.

148. *Indianapolis Star*, "Crack Hoosier Pilot Dies Riding Air Mail," December 9, 1930, newspapers.com.

149. *San Antonio Express*, "Local Aviator Dies in China," December 10, 1930, ProQuest Historical Newspapers.

150. Ibid.

151. Ibid.

152. Ibid.

153. *Fort Wayne News-Sentinel*, "Baer's Funeral Group Selected," December 10, 1930, Allen County Library Genealogy Microfilm.

154. *San Antonio Express*, "Legion to Honor Dead War Flyer," December 27, 1930, newspapers.com.

155. *Garrett Clipper*, "Last Honors Paid to Fort Wayne Air Hero," January 3, 1931, newspapers.com.

156. *Fort Wayne News-Sentinel*, "Army Aviators Drop Wreaths from Air," January 3, 1931, Allen County–Fort Wayne Public Library, Genealogy Department Microfilm.

157. Ibid., "Baer's Funeral Group Selected."

158. Ibid.

159. *Fort Wayne Journal-Gazette*, "Thousands Pass Bier of War Ace," January 3, 1931, Allen County–Fort Wayne Public Library, Genealogy Department Microfilm.

160. Ibid.

161. *Fort Wayne News-Sentinel*, "Eight Fliers from Selfridge at Mount Clemens Act as Honorary Pallbearers at Funeral of Paul F. Baer," January 4, 1930, newspapers.com.

162. Ibid., "Funeral Is Held," January 3, 1931, Allen County–Fort Wayne Public Library, Genealogy Department Microfilm.

163. Harnish, *Paul Baer Scrapbook*, vol. 31, no. 8, 30.

164. *Fort Wayne News-Sentinel*, "Thank Helpers in Baer Rites," January 2, 1931, Allen County Library Genealogy Department Microfilm.

165. *Fort Wayne Journal-Gazette*, "Final Rites Today for Paul F. Baer," January 3, 1931, Allen County–Fort Wayne Public Library, Genealogy Department Microfilm.

166. *Fort Wayne News-Sentinel*, "Funeral Is Held."

167. *Fort Wayne Journal-Gazette*, "Courts Adjourned Friday Afternoon in Honor of Baer," January 3, 1931, Allen County–Fort Wayne Public Library, Genealogy Department Microfilm.

168. *Indianapolis News*, "Final Tribute Is Paid U.S. World War Ace," January 5, 1931, newspapers.com.

169. *Garrett Clipper*, "Last Honors Paid to Fort Wayne Air Hero," January 5, 1931, newspapers.com.

170. *Fort Wayne Journal-Gazette*, "Card Mailed Before Death of Paul Baer Received by Friend," January 4, 1931, Allen County–Fort Wayne Public Library, Genealogy Department Microfilm.

171. Ibid., "Thousands Crowd Streets, Cemetery," January 4, 1931, Allen County–Fort Wayne Public Library, Genealogy Department Microfilm.

172. *Battle Creek Enquirer*, "America's First Air Ace Given Military Funeral," January 4, 1931, newspapers.com.

173. Ancestry.com, "Paul Frank Baer, U.S. Headstone Applications for Military Veterans (1925–1963)," www.ancestry.com.

174. *Fort Wayne Journal-Gazette*, "Paul Baer's Mother Dies at Age 88," September 6, 1954, Allen County–Fort Wayne Public Library Genealogy Department Microfilm.

Postscript

175. *Tri-State Triangle*, "Commencement Set for December 14," December 5, 1968, newspaperarchive.com.

176. Cliff Milnor, "Now It's Settled?," *Fort Wayne Journal-Gazette*, June 30, 1966, Allen County Library Genealogy Department Microfilm.

177. Fort Wayne–Allen County Airport Authority, "Airport History," www.fwairport.com/airport-authority/airport-history.

In Their Honor

178. Hall and Nordhoff, *Lafayette Flying Corps*, vol. 1, vii.

INDEX

A

Aero Club of America 37
Aero Club of France 28
Allison, Ernest, CNAC senior pilot
 93
American Flying Club 71
American Red Cross 43
American Society for the Prevention
 of Cruelty to Animals 15
Armentieres, city of 40
Arnold, General Henry H. "Hap"
 11
Avord, city of 24, 28

B

Baer, Alvin E. 16
Baer, Alvin Webster "Buddy", Sr.
 birth 16
 relocation to Mobile, Alabama 16
 service in World War I 30
Baer, Arthur 16, 30
 service in World War I as
 quartermaster 30
Baer, Benjamin 16

Baer, Emma
 divorce from Alvin 16
Baer Field 109
Baer, Mabel Naomi 16, 17, 34, 67,
 91
 death 90
Baer, Paul Frank 16, 36, 37, 42, 84,
 85, 90, 95, 102, 103
 April 23, 1918, fifth victory 34
 chamber of commerce welcomes
 65
 earning brevet militaire 28
 first American to receive
 Distinguished Service Cross
 (DSC) 36
 leaves for China on Empress of
 Canada 93
 passport application in 1917 23
 promotion to corporal after
 earning brevet 28
 returned on USS Adriatic 46
 service with Indiana National
 Guard 20
 Shanghai (plane) 95
 shooting down of *Albatross*, first
 victory 34

Baker, Secretary of War Newton 46
Bar-le-Duc 32
barograph 28
Bear, Paul
 receives first lieutenant
 commission 32
Bert Blair Oil Company 83
Bleriot, Louis 31
Bleriot Rouleur 26
brevet militaires 25
Bureau de Recrutement 23
Buttermore, Amanda 16

C

Cadillac Automobile Company's
 School of Applied Mechanics
 17
Campbell, Lieutenant Douglas 34
Carl Hauck Funeral Home 98
Cassidy, Butch (Robert Leroy
 Parker) 15
Caudron G-3 25
Charly-sur-Marne 36
Château Thierry 36
chicory 26
China National Aviation
 Corporation 93
Coatsworth, C.J. 31
Collins, Phelps 36
Corporacion Aeronautica de
 Transportes (CAT) 89
crash helmet 24, 26
Croix de Guerre 36

D

Dixon, Jane, New York sportswriter
 77, 78, 79, 80, 81

Dreben, Sam, soldier of fortune 78
Dugan, William, Jr. 40
Dyer, Frederick E.
 divorce from Emma 17, 83
 marriage to Emma 16

E

Earhart, Amelia 90
Ecole d' Aviation 24
E.L. Smith Oil Company Inc. 84
Escadrille Americaine 22
Escadrille SPA 80 31
Escadrille SPA 124 32

F

15th Combat Group 32
Foellinger, Oscar 16
 death 16
Fort Wayne International Airport
 109
4th French Army 32
French Foreign Legion 23
French Military Aeronautics 22
Frey, Royal D. 32
Frick, Ford 107

G

George, David Lloyd, British
 politician and statesman 111
Giroux, Ernest A. 40
Graudenz, German prison 40, 42,
 43, 44, 46, 52, 57
 description 52
Gros, Dr. Edmund L. 23
Groupe des Divisions
 d'Entrainment 28

H

Hall, James Norman 36
Hankow 94, 95
Harnish, Herb 16
Harrison, Benjamin, President
 100
Hoffman, E.G., owner of the
 Journal-Gazette 85
Hogg, U.S. Representative David,
 Republican from Indiana 98
Hosey, Mayor William J., Fort
 Wayne 84, 85, 98
Hotel des Invalides 23

I

Indiana National Guard, Mexican
 Border Campaign 19
International Aeronautical
 Federation license 28

J

James, Jesse 15
Janis, Elsie, entertainer 72
Jasta 18, German squadron that
 shot down Baer 40
Joint Army and Navy Board of
 Aeronautics 72
Jordan-Rozwadowski, General
 Tadeusz, of the Polish
 military 74

K

Keller, Helen 15
Kitty Hawk 11

L

Lafayette Flying Corps 21
La Tourette Driggs, Laurence 11
Law, Major Bernard 88, 89, 90
Legion of Honor 36
Lenin, Vladimir Ilyich, Bolshevik
 leader 72
Lindenwood Cemetery 90, 98, 100,
 103
Loening, amphibious aircraft 94, 95
Lufbery, Major Raoul 37

M

McCook Field (Dayton) 84
Milnor, Clifford J. 107
Moewe, German prison 40

N

94th Aero Squadron 34
Nungesser, Captain Charles 84, 85

O

103d Pursuit Squadron 32

P

Paderewski, Ignacy, Polish premiere
 73, 79
Pan American Airways 90
Pan, K.F., as Baer's copilot on final
 flight 95
Parent, Emeline 15
 death 16
Parent, Hiram 15
 death 16

Paul Baer Scrapbook 16
Paul Frank Baer Field 84
Penguin class 26
Pershing, John J. 19, 37, 46, 89, 98, 102
Phelps, A.T., San Antonio architect 96
Plessis-Belleville 28

R

Red Cross Bureau of Prisoners' Relief 44
Rediger, Reverend B.E., officiant at Baer's funeral 98
Red Stockings 15
Rheims 37
Rheno, Walter 31
Rickenbacker, Edward V. 37
Rockwell, Robert 36
Rome City 107
Rotary Club, and plans to honor Baer 65
Runser, Lieutenant Harry 46

S

Sanderson, John, CNAC secretary 96
Selfridge Field 98
Shroyer, Martin D. 105
 Emma's third marriage 83
Smith Field 109
Smith, Harry, CNAC operations manager 93
Société Pour Aviation et ses Derives (SPAD) 29, 31, 32
Société Pour les Appareils Deperdussin 31

Spad, 180-horsepower 32
Spad S.XIII, shot down 40
SS *Rochambeau* 23
Sullivan, Anne 15

T

Taft, William Howard 46
Thaw, William 32
tunnels, plans for prison escape 53, 54, 55, 56, 58, 59, 60
Turnure, George 40
21st Combat Group 32
23 Avenue du Bois de Boulogne 23

U

U.S. Department of Commerce 88

W

Wabash Railroad 47
Whangpoo River 95
White, Willian T., wrote letter about Baer's status as first ace 108
Wilcox, Charles H. 31, 32, 40, 42
Wild Bunch gang 15
Wilson, President Woodrow 36, 47
Wright, Orville and Wilbur 11

About the Author

Tony Garel-Frantzen worked as an award-winning reporter and editorial cartoonist for five years before embarking on a successful career as a public relations consultant and corporate communications executive. His first book, *Slow Ball Cartoonist: The Extraordinary Life of Indiana Native and Pulitzer Prize Winner John T. McCutcheon of the* Chicago Tribune, was published by Purdue University Press in 2016 and is an official Legacy Project of the Indiana Bicentennial Commission. Tony is a military aviation enthusiast and soloed his first plane, a Piper Cub J-3, in 2003. He and his wife have three grown children and live in Illinois with two dogs.

Visit us at
www.historypress.net